DRAW
EVERY LITTLE
THING

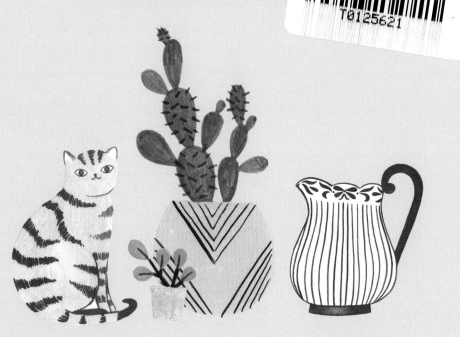

LEARN TO DRAW MORE THAN 100
EVERYDAY ITEMS, FROM FOOD TO FASHION

Flora Waycott

Brimming with creative inspiration, how-to projects, and useful information to enrich your everyday life, Quarto Knows is a favorite destination for those pursuing their interests and passions. Visit our site and dig deeper with our books into your area of interest: Quarto Creates, Quarto Cooks, Quarto Homes, Quarto Lives, Quarto Drives, Quarto Explores, Quarto Gifts, or Quarto Kids.

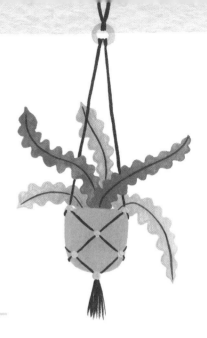

First published in 2019 by Walter Foster Publishing, an imprint of The Quarto Group. 26391 Crown Valley Parkway, Suite 220, Mission Viejo, CA 92691, USA.
T (949) 380-7510 **F** (949) 380-7575 **www.QuartoKnows.com**

Walter Foster Publishing titles are also available at discount for retail, wholesale, promotional, and bulk purchase. For details, contact the Special Sales Manager by email at specialsales@quarto.com or by mail at The Quarto Group, Attn: Special Sales Manager, 100 Cummings Center, Suite 265D, Beverly, MA 01915, USA.

ISBN: 978-1-63322-801-6

Digital edition published in 2019
eISBN: 978-1-63322-802-3

Printed in China
10 9 8 7 6

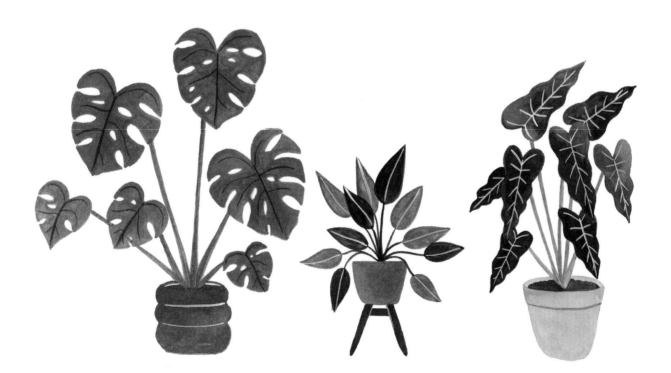

TABLE OF CONTENTS

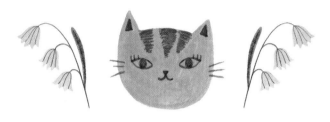

INTRODUCTION

Hello! My name is Flora, and I am an artist and illustrator based in Australia. I have loved to draw, paint, and make for as long as I can remember. My father is a writer and my mother is also very creative; I grew up watching her knit, make clothes, write Japanese calligraphy, and work on craft projects. From a young age, I was exposed to a creative world and knew early on that I wanted to be an artist, although what form that would take I hadn't yet discovered.

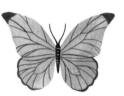

I studied textile design at art school and after working as a textile designer, my focus turned to illustration. This was not a difficult transition, as I had already been applying my drawings to textiles and knew how to work with color.

When it came to building a portfolio, however, I felt stuck. Where should I begin? I fantasized about all the exotic countries where I thought I should be traveling to find inspiration and new color palettes to energize my work. I do believe that travel can fuel new ideas, but it wasn't possible at the time, so I set myself a challenge to draw only the things in my immediate surroundings. I snooped through my cupboards and went for walks, taking notes and making sketches. I soon realized that the world around me contained an abundance of drawing inspiration.

As I made patterns and paintings and experimented with different tools and materials, my style started to emerge and objects that were dear to me appeared throughout my portfolio. A little bit of my personality was embedded in my art. Soon, my work was seen by art directors, eventually leading to illustration jobs. I now create art for various clients around the world, from book publishers to food-packaging and stationery companies.

In this book, I share ideas and tips for drawing every little thing you see around you. I encourage you to start at home and then venture out, all the while keeping your eyes open. Notice things you might typically overlook. Stop to take a photo or make a quick sketch. You will

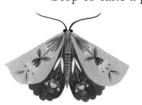

be surprised by just how much inspiration is waiting for you right on your doorstep!

HOW TO USE THIS BOOK

Draw Every Little Thing will take you on a journey through everyday objects and encourage you to look more closely at the world around you. What interesting objects can you find in your own surroundings?

The book is divided into four sections, with each one featuring ideas for drawing subjects as well as step-by-step drawing and painting tutorials. At the end of the book, you will find three crafting projects that will encourage you to apply your illustrations to fun, paper-based handmade items!

Within each section, learn to warm up and stretch your drawing muscles with creative prompts before working through the step-by-step tutorials in the exercises. Here, the art becomes a little more detailed and I've shared more about my process. You can refer to the useful information found in "Drawing & Painting Techniques" (see pages 12-19) for more in-depth instruction, learn about my favorite tools and materials (pages 8-11), and familiarize yourself with color basics (pages 20-23) before embarking on your drawing journey.

It's not necessary to follow each tutorial exactly, although I would encourage beginners to consider doing so. Once you are familiar with the basic principles, have fun applying the techniques to your own drawing subjects.

Wherever you are in your artistic journey, I hope you will find useful information throughout *Draw Every Little Thing* and that you will enjoy gathering inspiration from the world around you!

FINDING INSPIRATION

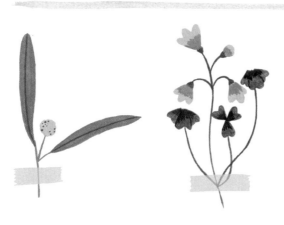

Inspiration is all around you, but it's how you interpret your sources of inspiration that makes them unique. I'm often asked where I get my ideas for my art, and my answer is always that it's a combination of things: my experiences, favorite colors, love of nature and tiny things, and personality.

Below are a few simple suggestions for finding your own sources of inspiration. These tips have become good practice for me, and I hope they will for you too!

Keep a Notebook

I carry a small notebook everywhere I go and fill it with notes, ideas, and sketches. I allow myself to scribble and make a mess in this notebook; it's full of starting points and possibilities. Choose a notebook with smooth, beautiful paper that you know you'll love to use.

Bring a Sketchbook

I like to use my sketchbook as a scrapbook; I stick in bits of paper, plants, and ticket stubs. When I find a color palette I love, I paint swatches into my sketchbook as a record. It contains rough sketches, experiments, and mistakes, and it's taken me a long time to learn that I don't have to be too careful with it!

Rummage Through Your Cupboards

Take a walk through your home and look through your cupboards. Find five of your favorite objects to draw. I often do this as an exercise and find that it really stretches my drawing muscles. Sometimes I'll find an object that I'd forgotten about or something with an unusual shape that sparks a fun new idea!

Go to the Library

I love spending time in the library and flicking through old books. It gives me a break from going online, and I always seem to find something unique. Nature and crafting books are my favorites, especially old ones that are full of interesting images and nuggets of inspiration.

Visit a Museum

A museum is one of the best places to go when you feel like you need new ideas and some direction. I especially love to visit natural history, folk art, and textile museums.

Bring a sketchbook and a pencil, and challenge yourself to make a few quick sketches of objects or patterns that catch your eye. Don't worry too much about what they will become; let yourself enjoy looking at new and unusual objects!

Take a Day Trip

Treating yourself to a day trip somewhere new can be just what the doctor ordered. Go by yourself or take a relative or a friend, and notice the differences between this place and your own neighborhood. Is there a quirky café? What's the interior like? Is there a gift shop that sells unusual items you may want to draw?

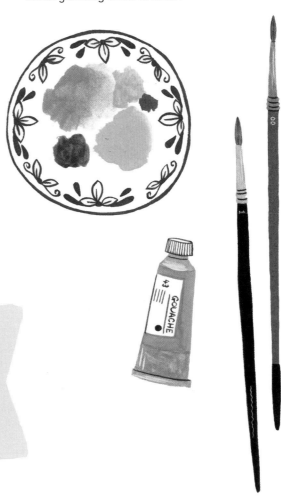

CONSIDER WHAT MAKES YOU UNIQUE AND BRINGS YOU HAPPINESS, AND IT WILL UNDOUBTEDLY COME THROUGH IN YOUR ART.

TOOLS & MATERIALS

You will want to start with a few basic tools, which I'll discuss over the next few pages, but keep in mind that part of the fun of creating is figuring out what works best for you. Also, remember that you can build your collection over time and don't need to own all of these items before learning to draw.

> BUY THE BEST MATERIALS YOU CAN AFFORD;
> THEY WILL LAST LONGER, AND THE QUALITY WILL BE BETTER.

Pencils

I start all of my pieces with a sketch using a traditional or a mechanical pencil. The latter is the most-used tool in my collection; I use one every single day. I have both 0.3 and 0.5mm mechanical pencils, and I prefer to use HB lead, which is wonderful for detail work and light sketching on watercolor paper or in a sketchbook. Mechanical pencils come with built-in erasers, making them ideal travel tools.

Black Fineliner Pens

This tool is excellent for creating consistent lines and final detail work. I like to use a size 02, but I also keep sizes 03 and 05 handy for creating slightly thicker lines.

Nib Pen & Ink

The nib pen produces a variety of interesting marks and inconsistent lines, so it works well for experimentation and can create exciting results. I like to use a nib pen over paint or by itself to give a loose, hand-drawn look to my art.

Erasers

I use a standard block eraser for larger areas and a stick eraser for detail work. With a stick eraser, you can erase tiny portions without ruining the paper or smudging the rest of your artwork.

Paintbrushes

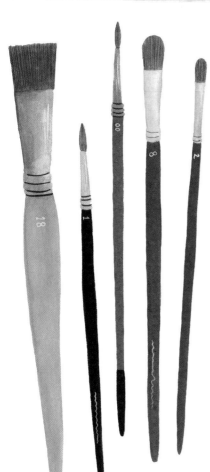

I use fine-tipped brushes in sizes 0 and 00 for my detail work, and I keep slightly larger flat brushes on hand as well for filling in larger areas. For background washes and to create more coverage, I use a very large flat brush in size 18.

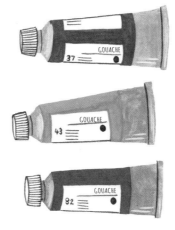

Gouache

Gouache is my favorite type of paint and my first choice for adding color to my artwork. Like watercolor, gouache is water-based, but it produces an opaque look with a matte finish and bold, intense colors. If gouache dries on the palette, it can be watered down and reused.

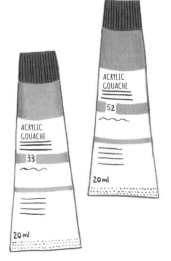

Acrylic-Based Gouache

Acrylic-based gouache, which is similar to both gouache and acrylic paints, produces an opaque look and intense color, dries with a matte finish, and is water-soluble when wet. Unlike gouache, it becomes water-resistant once dry, so it works well for layering colors, as it won't budge or bleed. Once dry on the palette, it's no longer water-soluble, so I recommend using a moisture-retaining palette (page 10) to minimize waste.

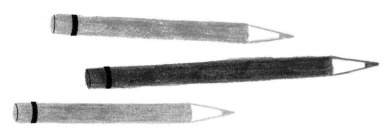

Colored Pencils

I like to use colored pencils alone or over paint to add texture. There are so many colors available; you can really play around with colored pencils. Use artist-grade pencils, as they are softer and creamier.

WHEN CHOOSING PAINTS AND COLORED PENCILS, RATHER THAN BUYING A SET, SELECT THE COLORS INDIVIDUALLY ACCORDING TO YOUR FAVORITES. THIS WILL ENSURE THAT YOU USE ALL OF YOUR COLORS!

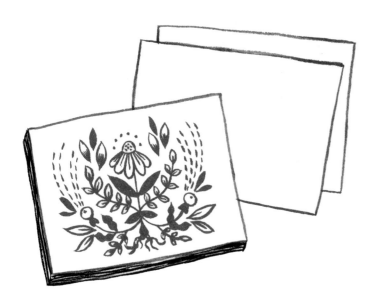

Paper

For fineliner pen and pencil work, I like to use a smooth, acid-free drawing pad with 200gsm paper. Its smooth surface allows the pen to glide effortlessly, producing excellent results.

With paint, I prefer hot-pressed, 300gsm paper. It comes in pads, as large sheets that can be cut down, and as paper blocks, which have paper that's glued on all four sides. This reduces the risk of the paper warping when painted on; you can use a palette knife to separate the sheets once the paint is dry.

THE SMOOTH SURFACE OF HOT-PRESSED PAPER IS IDEAL FOR ARTWORK THAT WILL BE SCANNED ONTO YOUR COMPUTER.

Palettes

Have several palettes on hand. I like to use ceramic dishes and the large plastic palettes found in art stores.

Moisture-Retaining Palette

Designed to keep paints moist and usable for weeks, this palette works well with acrylic-based gouache (page 9). To make your own, soak a thin sponge or a sheet of watercolor paper in water, and then place greaseproof paper on top. Pour your paints onto the greaseproof paper and use the palette as you normally would, with the water soaking into the paper. When you finish painting, place a lid over the palette to keep the paints inside moist.

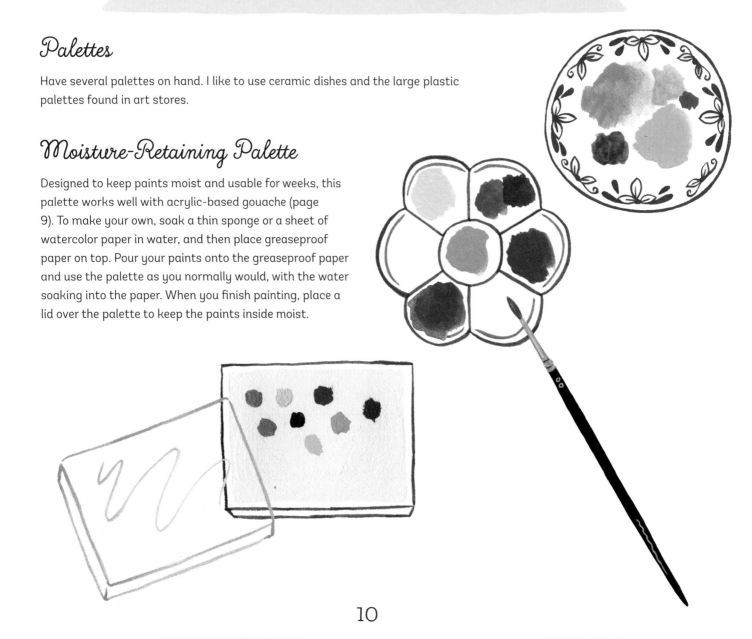

MORE USEFUL ITEMS

When I travel, I store my brushes in a bamboo brush roll, which allows the brushes to breathe and protects them during transport. Some rolls come with built-in fabric pockets that separate the brushes.

Other items I always have with me include:

- A ruler

- A pencil sharpener

- Paper towels for soaking up excess water on a paintbrush

- Scratch paper (I use leftover watercolor paper to test my colors before painting)

- Masking tape for taping down the edges of sheets of paper

- Glass jars or ceramic cups to hold clean water for painting

- A light box for transferring images

I STORE MY BRUSHES HORIZONTALLY ON MY BAMBOO BRUSH ROLL. THIS WAY, WATER DOESN'T DRIP DOWN THE BRUSH HANDLES, MINIMIZING THE RISK OF DAMAGE.

DRAWING & PAINTING TECHNIQUES

This section introduces you to some of the drawing and painting tips and techniques I often use in my work. I hope you will find them useful for the prompts, exercises, and step-by-step projects starting on page 26!

Transferring a Sketch

I like to sketch what I plan to draw or paint before diving into the final art to avoid ending up with unexpected results! Being a bit of a perfectionist, I usually map out my ideas on printer paper, and then transfer them onto watercolor paper, following the steps below, before beginning my final piece.

STEP 1 Place your sketch on top of a light box and tape down the corners. If you don't have a light box, you can tape your sketch to a window during the day.

STEP 2 Lay your final artwork paper (such as a sheet of watercolor paper) on top of the sketch and tape down the corners.

STEP 3 Lightly trace your sketch. You want as few pencil lines on your final art paper as possible, so trace the main shapes but not the small details. When you work on your final artwork, you can fill in the details by referring to your sketch.

STEP 4 Remove your final art paper from the light box. It's now ready for your chosen medium, whether it's gouache, colored pencils, acrylic paint, or something else entirely!

Alignment

When drawing a symmetrical subject, adding a vertical line down the center of your sheet of paper can help ensure accurate placement. Draw half of the subject on the left side of the paper; then draw its mirror image on the right side of the line. The final drawing won't be exactly symmetrical, but I find this adds to the artwork's charm!

If you prefer to create perfect symmetry, follow these simple steps:

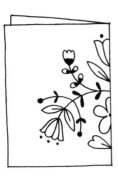

STEP 1 Fold a sheet of paper in half and draw half of your design on one side.

STEP 2 Turn over the sheet of paper and, with the drawing side down, place the paper on a light box or window, and tape down the corners. Trace the design onto the other half of the paper.

STEP 3 Unfold the paper to reveal your perfectly symmetrical design!

Black Gouache & a Fine-Tipped Brush

I often use this technique to allow for looser, more fluid lines, which give my drawings an effortless look. It's perfect for warm-up exercises as an alternative to using a pencil, and it's also excellent for creating detailed work, as you will see in this book.

On a palette, mix a small amount of water with black gouache, aiming for the consistency of melted ice cream and adding more water if necessary. Don't allow the paint to become too transparent; the color should be strong and opaque. With the tip of a fine-tipped brush, make thin, fluid lines to create your shapes.

Painting Techniques

Gouache is my favorite medium for adding color to my artwork. A water-based paint, gouache creates an opaquer appearance than watercolor. Mix in less water for bolder colors (this is my personal preference), or water it down for transparency. The chart below shows this progression using a single paint color.

Less water added More water added

Blending Paint

Colors can be blended when the paint is wet or dry to achieve different effects. In the squares below, the colors were blended when the paint was wet, causing the colors to bleed into each other and create an ombre effect.

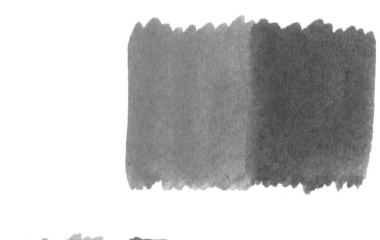

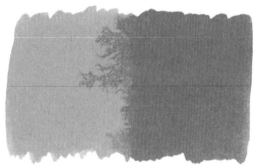

Compare the squares on the bottom of page 14 with the plants here, which show darker shades added after the subject's main color has dried. Notice the clear contrast between the two types of blends!

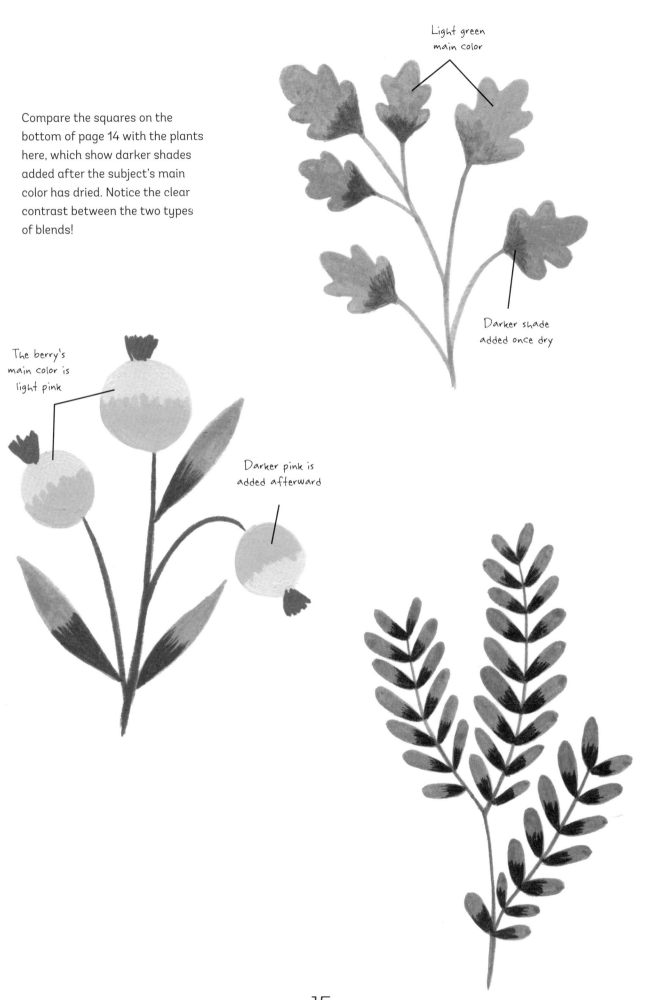

Light green main color

Darker shade added once dry

The berry's main color is light pink

Darker pink is added afterward

Adding Details

I like to add small details, such as lines and dots, to bring my paintings to life. Practice a few ideas like the ones below, and then apply them to your artwork. These small details can make a huge difference in the overall look of your artwork!

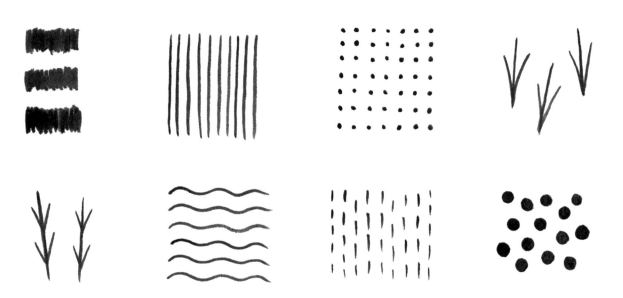

To achieve a high level of contrast, use white gouache mixed with a very small amount of water, plus a fine-tipped brush. Paint the leaf first and let it dry completely before adding details.

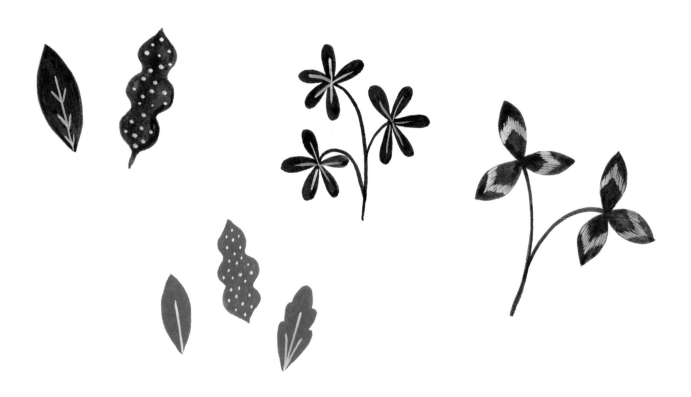

Details with Tints & Shades

Add details using darker or lighter tones of your subject's main colors to create a harmonious effect. For a darker shade, add black to the main color; for a lighter tint, add white. (For more information on tints and shades, see page 21.)

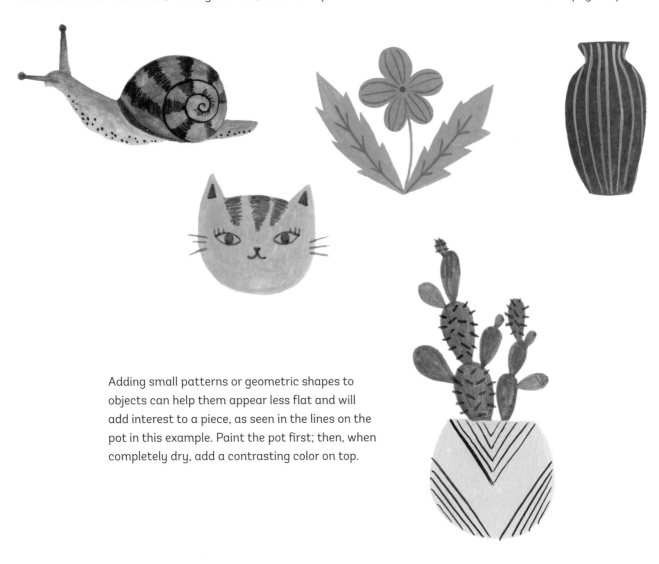

Adding small patterns or geometric shapes to objects can help them appear less flat and will add interest to a piece, as seen in the lines on the pot in this example. Paint the pot first; then, when completely dry, add a contrasting color on top.

Colored Pencils

I like to use colored pencils alone or over paint to add texture. Here you can see different tones blended together. The middle area of each square shows the two tones mixed together.

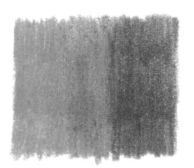
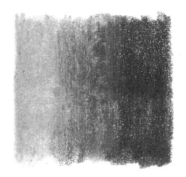

Here you can see the contrast between smooth, solid paint and the rough lines of colored pencils.

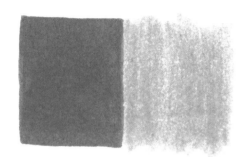

Applying white colored pencil over a dark shade of paint creates a high level of contrast and textured lines.

These images show colored pencil details added over dry paint.

Backgrounds

You can add a background to your artwork before or after drawing the main subject. I prefer to work on the background first, as shown here; I color in the subject after letting the background dry.

NOTES

You can also create an area of flat color and then work on top of it. Here, I used a cream color to contrast with the blue background. I recommend using acrylic-based gouache for this technique so that the background is water-resistant when dry.

A colored pencil background creates an interesting contrast with paint, as shown here.

To create clean edges around your painting, tape down the four sides of the sheet of paper using masking tape to form a square. Paint inside the square, making sure to paint over the tape's edges. Removing the tape leaves you with clean edges.

COLOR BASICS

When asked what my favorite color is, so many colors come to mind that I often struggle to pick just one. My favorite color changes all the time depending on my mood, inspiration, whereabouts, and current work projects. However, I do have certain preferences—and chances are you do too! Just like choosing clothes or home décor, you will have your own color and style choices, and these will come through in your art.

Understanding color can be confusing if you are not used to working with it. Over the following pages, we'll explore basic color theory and useful tips for finding color balance and harmony. With these techniques, you can start to build your own color palettes.

Color Wheel

The color wheel is a helpful tool for learning about colors and color harmony.
This wheel shows primary, secondary, and tertiary colors.

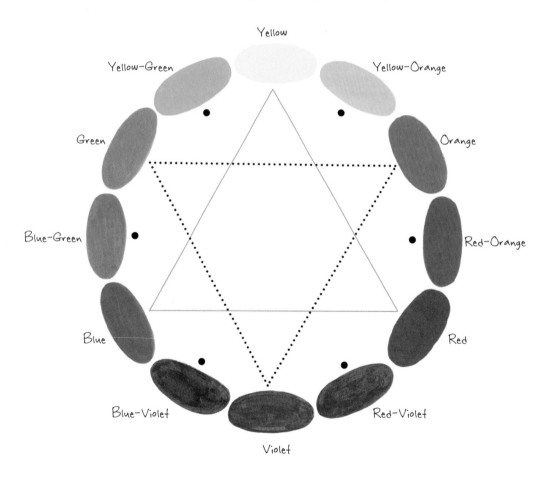

——————— Primary Colors • • • • • • • • Secondary Colors ● Tertiary Colors

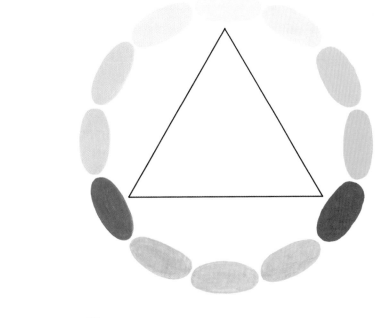

Primary Colors

All colors are derived from the three primary colors: yellow, red, and blue.

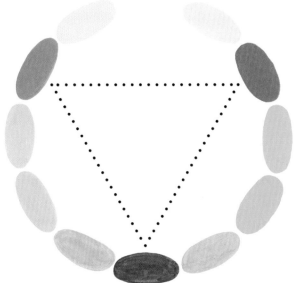

Secondary Colors You can create the secondary colors—green, orange, and violet—by mixing the primary colors on either side of them, according to the color wheel. Mix blue and yellow to make green, yellow and red to make orange, and red and blue to make violet.

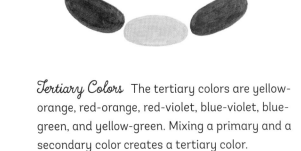

Tertiary Colors The tertiary colors are yellow-orange, red-orange, red-violet, blue-violet, blue-green, and yellow-green. Mixing a primary and a secondary color creates a tertiary color.

Tints & Shades

When you wish to lighten or darken a color, use a tint (to lighten) or a shade (to darken). Create a tint by adding white to a color, or a shade by adding black. The lightness or darkness of the final color depends entirely on the ratio of white or black to the main color.

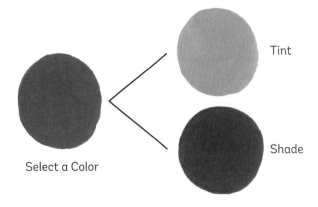

Tint

Shade

Select a Color

Color Harmony

Here I've included some basic formulas for creating color harmony, or colors that are used together for a pleasing and harmonious look. These are not meant to be rules that you must follow; however, the principles are important and will help guide you if you're new to matching colors.

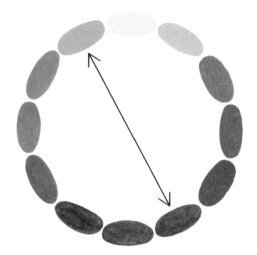

Complementary Colors
Complementary colors sit directly across from each other on the color wheel. When placed next to each other, they create a high level of contrast, as you can see here.

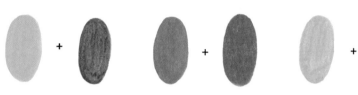

In these examples, I chose tints of red and shades of green.

Analogous Colors
Analogous colors sit side by side on the color wheel and can give a design a calm, serene look.

Triadic Colors
Triadic colors are evenly spaced around the color wheel. They tend to display a high level of contrast, so I like to create my own hues using tints and shades and by mixing my own versions of colors from around the wheel.

I often work with these three colors. Try creating your own color combinations using these color harmony basics.

Color Palette Examples

The color balance in this garden pattern creates a calm, harmonious feeling thanks to the many green hues used together. Notice how the complementary shades of peach, bright pink, and red are used sparingly around the design, providing interest without overwhelming the senses.

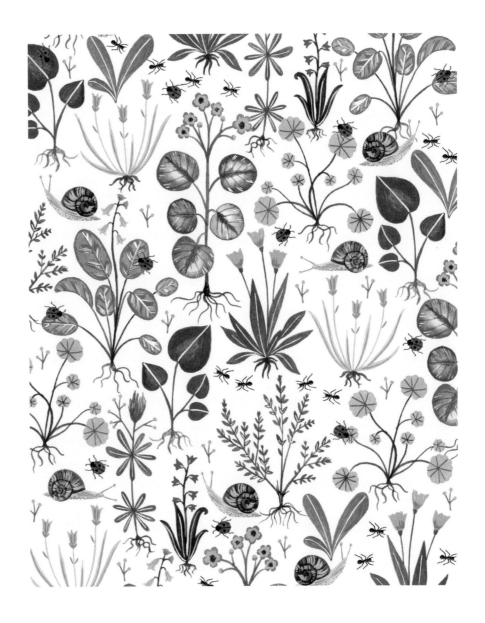

Play around with mixing cool colors (such as blues and greens) with warm colors (red, pinks, and oranges). Experiment with using dark as well as light tones to create maximum contrast.

Although these designs show high levels of contrast, their color palettes are limited and carefully chosen to keep the artwork sophisticated and refined.

AROUND THE HOME

In the book's first section, let's explore the items found around your home that you encounter every day. Your home is your personal space, full of treasures that you love and cherish. Open your cupboards and closets, admire your houseplants, and get ready to take a closer look at your favorite objects!

VASES

You likely own at least a few vases of different styles and shapes. You may even collect them, like I do! Let's explore drawing various vases using only black gouache, which will allow you to focus on the forms and details.

WITH A SMALL ROUND BRUSH, MIX A BIT OF WATER INTO THE PAINT. YOU'LL WANT TO CREATE A DARK, OPAQUE LINE, SO THE PAINT MIXTURE SHOULDN'T BE TOO WATERY.

 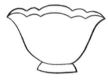 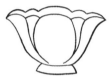 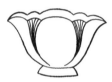

Draw the wavy opening of the vase; then add the fan-shaped outline and the base before adding the interior details.

 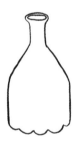 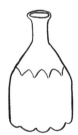 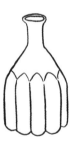

Start with a small oval for the opening and move downward to draw the rest of the vase. Zigzag and vertical lines complete the vase.

Draw the oval-shaped opening, followed by a teardrop with feet at the bottom. Add the hair and facial features, with circles for the cheeks.

Start with the swan's beak and then draw the head, neck, and feathers.
Complete the swan's shape and add details, like small U-shaped feathers on the chest.

 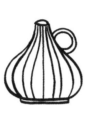

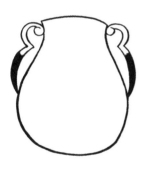

Here are additional vases to use as drawing inspiration. These can be photocopied and traced using a light box or tracing paper. Take a look at your own vase collection for even more ideas!

 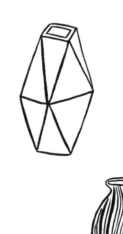 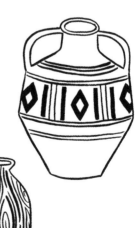

TODAY'S OUTFIT

Let's have some fun with your wardrobe! Documenting your outfit every day makes for great drawing practice, and you don't even need to leave your home to carry out this daily challenge!

Over the next few pages, we'll cover wardrobe essentials.
Practice drawing these shapes and then, as your confidence grows, try adding patterns or varying the shapes to draw your own favorite clothing items.

 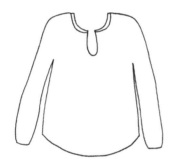

Pleated Blouse

Create the neckline before moving to the sleeves and body of the blouse.
Add cuff and seam details, and then draw a bow and pleats for a dressy-looking blouse.

Fuzzy Sweater

Begin with the neckline; then draw the main shape of the sweater before adding details to the cuffs and hem.
To create the look of wool, draw a random "V" pattern all over.

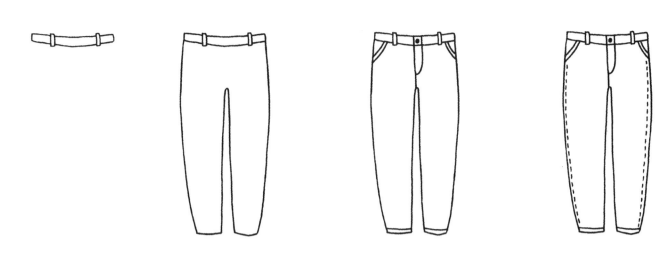

Jeans

First, draw the waist and belt loops. Using the waistline as a guide, add the legs, zipper, pockets, and cuffs.
Then draw stitching down the outside of each leg.

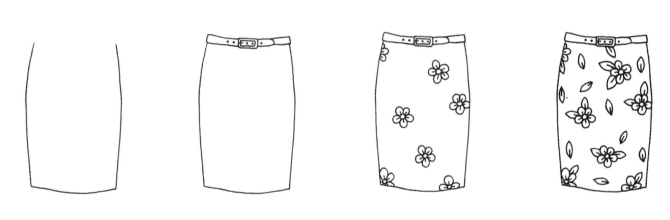

Floral Skirt

Draw the shape of the skirt and add a belt.
Randomly draw flowers and fill any gaps with leaves to complete the pattern.

Patterned Shorts

Draw the basic shape of a pair of shorts, and add a waistband and cuffs.
Create pockets and a central seam, and finish with a simple pattern.

Lace-Up Shoes

Start with two ovals, and add a sliver of the sole at the top of each shoe. Draw the flap details before adding laces.

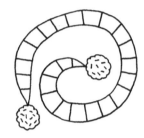

Pom-Pom Scarf

Draw a snake-like shape with tapered ends and pom-poms.
Add stripes; then make dashed lines going in different directions to convey the fluffiness of the pom-poms.

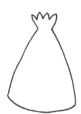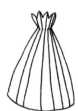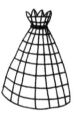

Checkered Drawstring Bag

Outline the bag and add vertical stripes, ensuring that they taper in at the top.
Then make horizontal stripes and a thicker line at the top of the bag, and add a strap.

Polka Dot Socks

Draw two socks and add toe and heel details. The dots complete the look!

Once you've practiced drawing a few items of clothing, try grouping them to create outfits. Start by drawing what you're wearing today. Draw three or four items, and then combine them like in the examples below. Don't forget to add details!

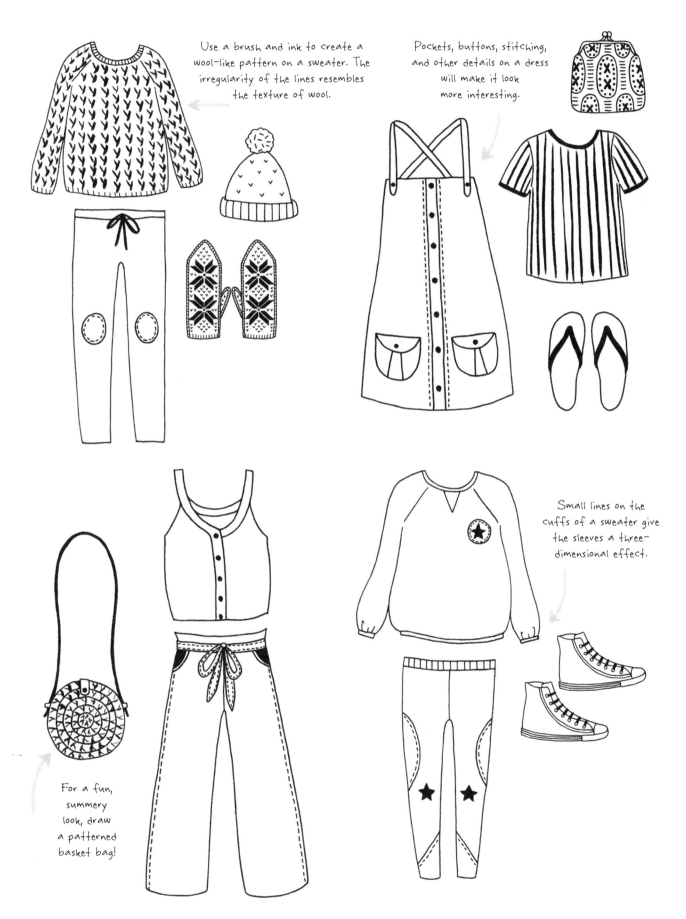

Use a brush and ink to create a wool-like pattern on a sweater. The irregularity of the lines resembles the texture of wool.

Pockets, buttons, stitching, and other details on a dress will make it look more interesting.

Small lines on the cuffs of a sweater give the sleeves a three-dimensional effect.

For a fun, summery look, draw a patterned basket bag!

31

PETS

I have a gray cat named Shima whom I often feature
in my artwork. I like to observe her in different poses
and get lots of drawing inspiration from watching her.

This creative prompt will give you tips on how to approach drawing animals,
whether they're your own pets or someone else's!

**USE A 0.5MM HB MECHANICAL PENCIL, AND KEEP
A STICK ERASER ON HAND FOR ERASING SMALL AREAS.**

Cats

Start with the pointy ears and round face. Create a fluid line for the cat's back and tail;
then add the legs and a round belly connecting the two. Lastly, fill in the details.

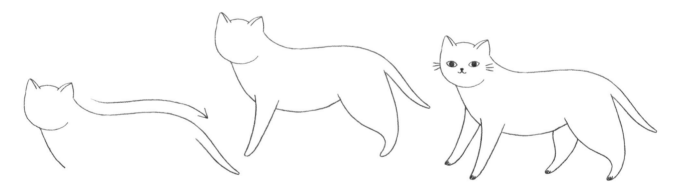

Now draw cats in different poses!

Draw striped
lines with a
pencil to create
a tabby cat.

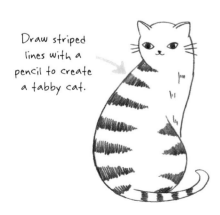

Adding eyelashes to
closed eyes makes
a cat look sweet
and friendly.

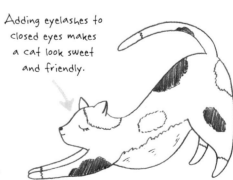

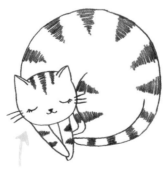

When drawing a sleeping cat, start
with the head before drawing the
round shape of the body.

Dogs

Draw the dog's face in profile. In this example, the dog has a square muzzle and a pointy nose.
Then add the body, using a fluid line for the back and tail. The jagged line on the underside of the tail implies fur.
Draw legs and facial details, shade the ear, and add wispy lines to create dimension.

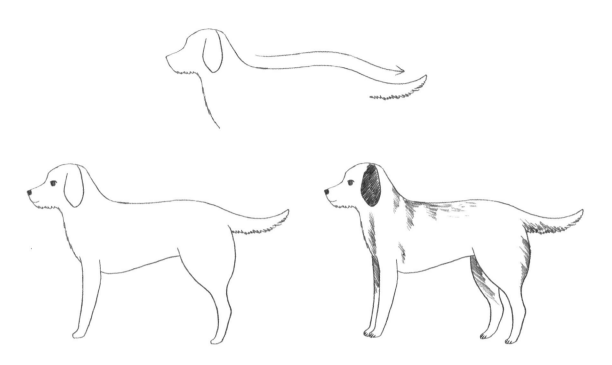

Here are a few dog breeds to practice drawing.

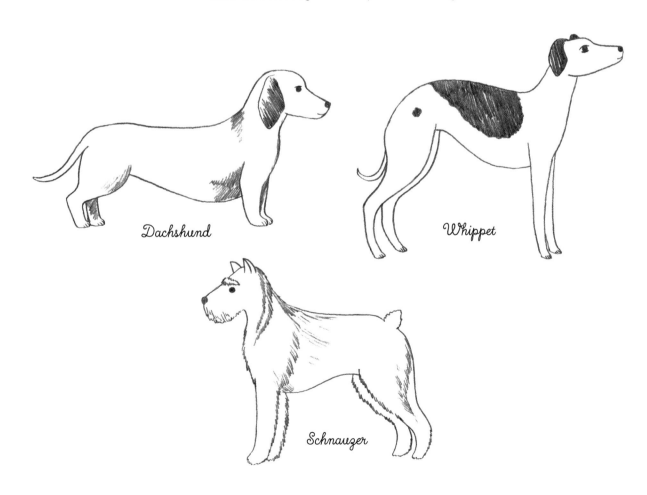

Dachshund

Whippet

Schnauzer

Rabbit

Draw the ears and an egg-shaped face, with a slight point for the nose. From the head, draw an arched back and a protruding chest. Keep the lines jagged to resemble fur. Draw the two front paws and the back leg; then add a round, fluffy tail and facial features. Small lines inside the tail create a soft, fluffy effect.

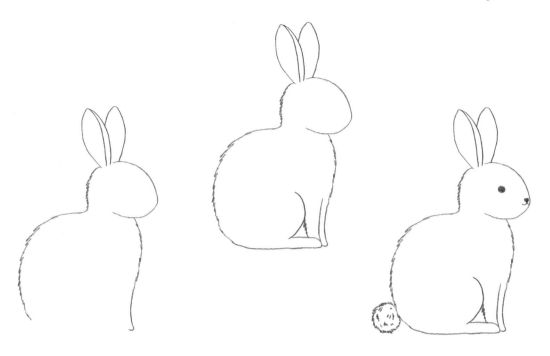

Goldfish

Draw the fish's mouth and oval body, with a point at the end. Then add fins and a tail. Next, draw an eye, gills, and scalloped lines to resemble scales. Finish with details!

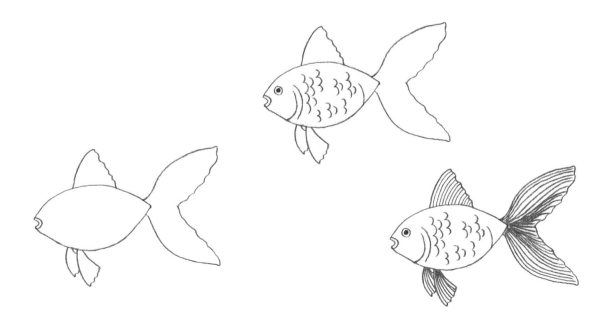

Cockatiel

Start by drawing the long, thin feathers on the bird's head. Then draw the head, beak, body, feet, and perch. Add tail and wing details using neat, vertical lines to indicate feathers. Finish with a round dot for the eye, details on the face, and U-shaped feathers on the chest.

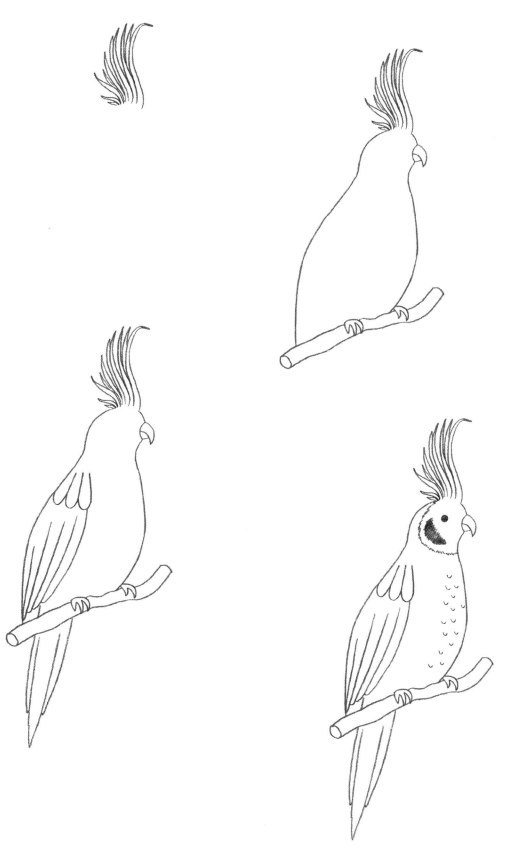

TEA TIN

Growing up in England and Japan, tea has always been a part of my life. I love everything about it, from opening the beautifully patterned tin to brewing and pouring my tea before sitting down to enjoy a cup.

To create a tea tin with a playful folk pattern, start with a sketch. The design is detailed, and you want to ensure that it will look balanced. Use cartridge or printer paper, as you will transfer your design onto watercolor paper.

1

Make a vertical line down the center of your paper. Using this as a guideline, draw a tea tin and its lid.

USE A 0.5MM MECHANICAL PENCIL TO CREATE THE TINY DETAILS IN THIS PIECE.

2

Working on the left side, draw half of the tea label and scalloped details in the corners. Then add a floral pattern around the label.

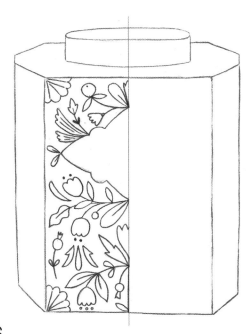

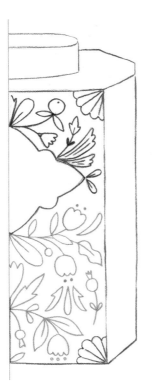

3

Fill in the pattern on the right side. You can do this by folding your design in half along the vertical line and using a light box or window to trace your drawing, or just draw it without any help. I enjoy slight imperfections in my art, so this is how I usually work. (See page 13 for tips on creating a symmetrical image.)

4

Add a pattern to the side panels of the tea tin. Keep the pattern simple so that it complements the main design without overwhelming it.

With a light box or a window, trace your design lightly onto watercolor paper. (See page 12 for instructions.)

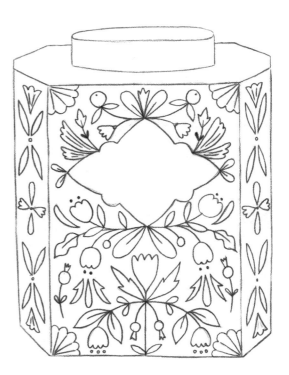

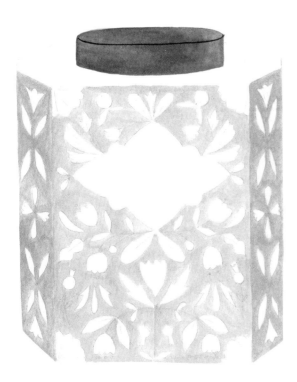

5

Use gouache paint for the background, leaving the pattern blank. Mix a tiny bit of black into the background color, and paint the side panels. Using a darker color here will create dimension. Also paint the tea tin's lid.

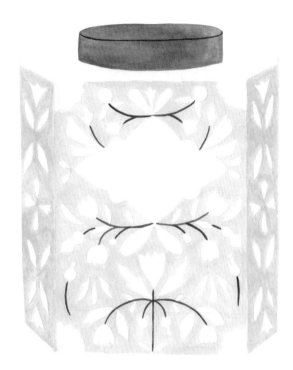

6

Paint the plant stems using a darker color that stands out against the background.

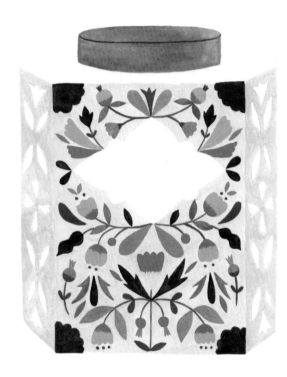

7

Fill in the main elements of the pattern using various colors.

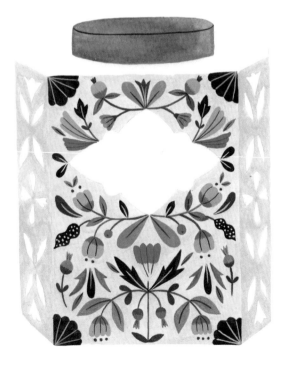

8

Now for my favorite part: adding little details! Using a size 00 brush and a steady hand, paint lines on the flowers and dots on the leaves. This step will make your design come to life!

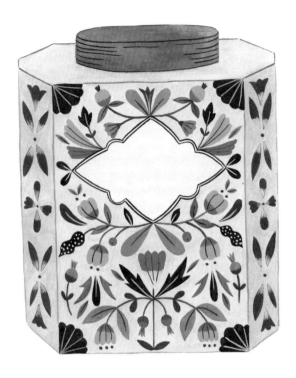

9

Fill in the pattern on the side panels and add lines that resemble ridges to the lid. Use a watery wash of light gray paint to fill in the area of the tin just below the lid. Also paint the tea label and outline the tea tin.

10

With a nib pen and black ink, hand letter the name of your favorite tea variety on the label.

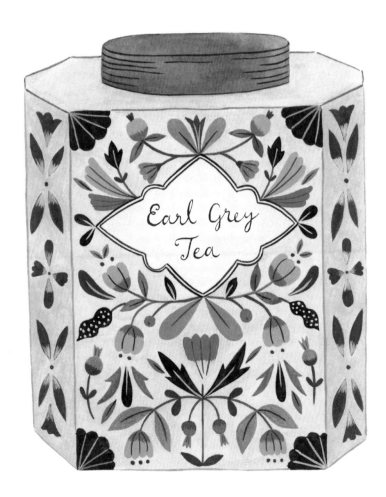

Earl Grey Tea

KITCHEN SHELVES

The kitchen is one of my favorite rooms in my home and where I spend a lot of time cooking, drinking tea, and flipping through cookbooks.

The kitchen also features many interesting shapes excellent for drawing practice. A couple of years ago, I started a personal project to paint the objects on the shelves in my friends' homes and my own. I love to draw small, so this exercise always excites me, and I enjoy adding a unique pattern to a bowl and exaggerating the leaves of a plant.

1

Start by looking through your cupboards and shelves for inspiration. Then make a rough pencil sketch, scattering items across several shelves. Add details like hanging bunches of herbs, a pot holder, and a tea towel.

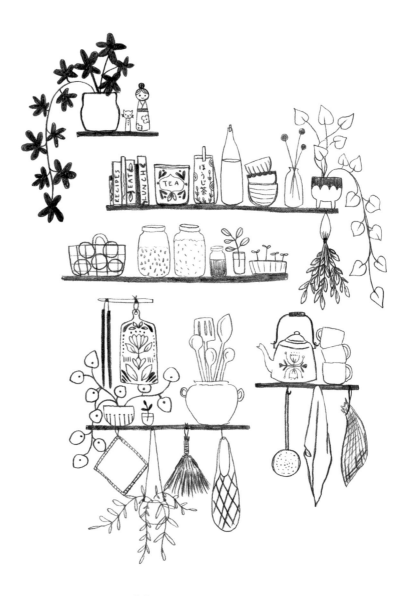

2

Use a light box and a pencil to lightly transfer your sketch onto a sheet of watercolor paper. If you don't have a light box, tape your sketch to a window, and lay watercolor paper over it to trace.

With paint, begin to fill in the lines of the shelves. Use neutral colors, like gray or taupe, so that the objects on the shelves will stand out.

3

Add some of the main elements in your design, starting with the larger items. Once these objects are in place, it's easier to fill in the gaps with smaller items.

NOT ALL OF THE OBJECTS NEED TO BE FILLED IN WITH A SOLID COLOR. FOR EXAMPLE, I USED ONLY A THIN BRUSH TO ADD DETAIL TO THIS LINE-ART POT. IT LOOKS PRETTY AND DELICATE NEXT TO THE OTHER ITEMS.

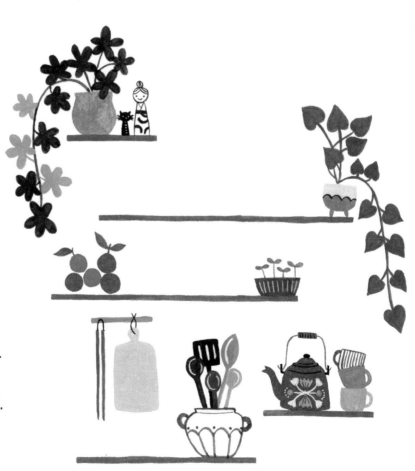

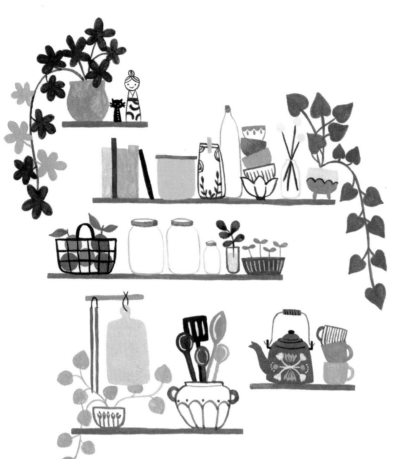

4

Paint the rest of the objects, nestling them in amongst the larger items. Consider the spacing between your objects, and if you add plants, play with drawing them surrounding the objects. This adds harmony to your final piece.

5

Add your final details, like the book titles, patterns on the tea canisters, and dish towels. Isn't it lovely seeing your favorite kitchen objects come together in one place?

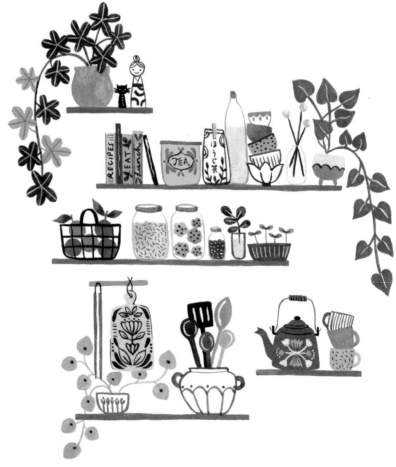

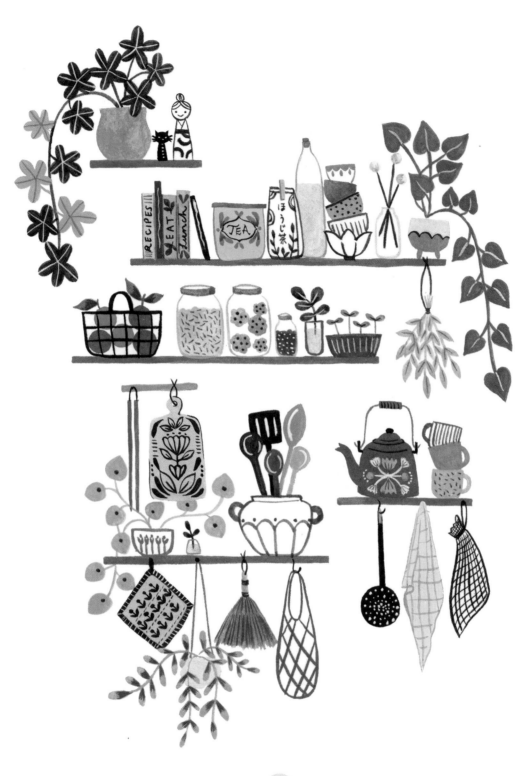

○ 6 ○

Finally, add hanging objects to the bottom shelves,
and check to see if details need to be added anywhere
else. If so, fill them in now.

Then frame your finished artwork and use it to
decorate your own kitchen!

HOUSEPLANTS & PETS

Anytime I move into a new place, I make sure to start a houseplant collection. Surrounding myself with plants calms me, and the many varieties are a wonderful source of inspiration for my art. If you're anything like me, you probably have a collection of plants too; look around your home and see how many different leaf shapes you notice!

USE A 0.5MM MECHANICAL PENCIL TO SKETCH; TO ADD COLOR, USE GOUACHE.

Alocasia

Pilea

Peace Lily

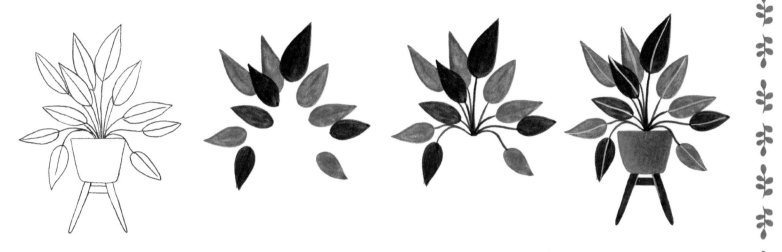

Fern

Monstera

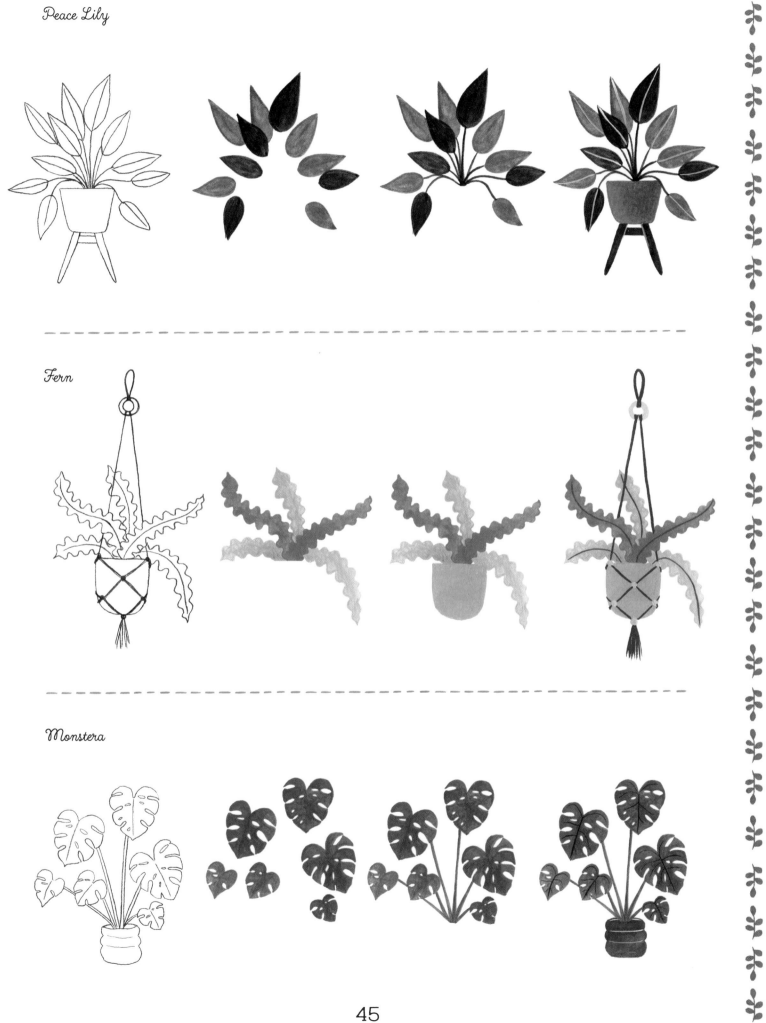

45

Now let's create a drawing featuring houseplants as well as pets! My scene includes two furry friends relaxing among plants during a cozy evening at home. You can trace the sketch, or perhaps you'd prefer to draw a scene from your own home featuring your favorite furry companion(s)!

1

Sketch your scene using an HB pencil; then lightly transfer it onto watercolor paper.

2

Paint the cat and dog with gouache, starting with their base colors and then adding their markings on top with a darker tone. Also paint the pots.

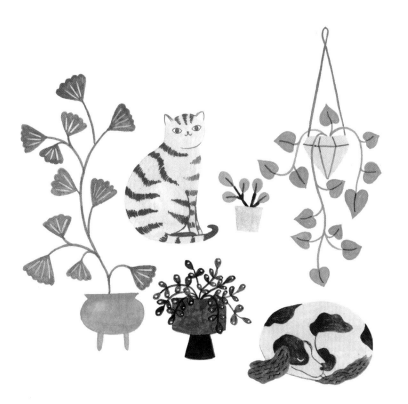

3

Paint the plants, including line and dot details within the leaves.

4

Lastly, add a cushion under the dog using colored pencil, and paint the window and dark blue sky behind the cat. Add falling snow to emphasize the cozy atmosphere!

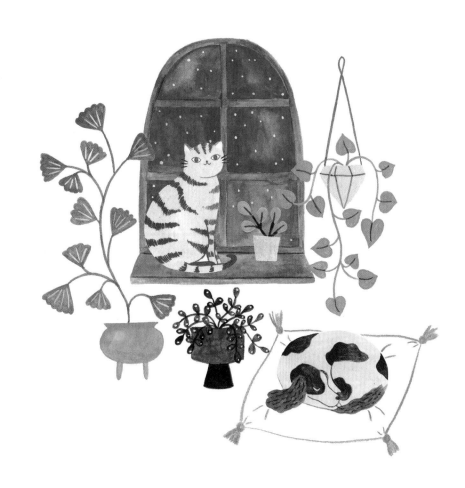

JAPANESE MEAL

Japanese meals are a feast for the eyes. Consisting of several small, seasonal dishes, they are beautifully presented with great attention to detail. They often include small bowls of rice and miso soup; a main course of fish, meat, or vegetables; and small dishes featuring tofu, salad, pickles, and sautéed vegetables. Everything is served in delightful ceramic bowls and dishes. Growing up in Japan, I loved eating this way, and I take special care to sketch or photograph my meals whenever I return. Drawing and painting these dishes preserves my memories forever.

SKETCH USING AN HB PENCIL; TO ADD COLOR, USE GOUACHE AND FINE-TIPPED BRUSHES.

Rice with Umeboshi (Fermented Plums)

Miso Soup

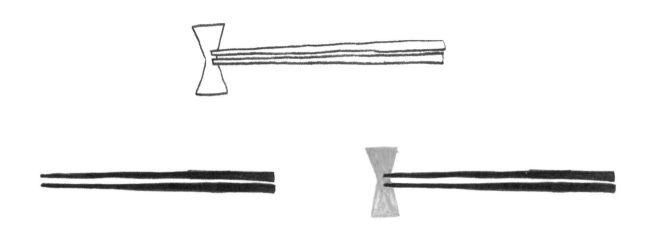

Chopsticks & Chopstick Rest

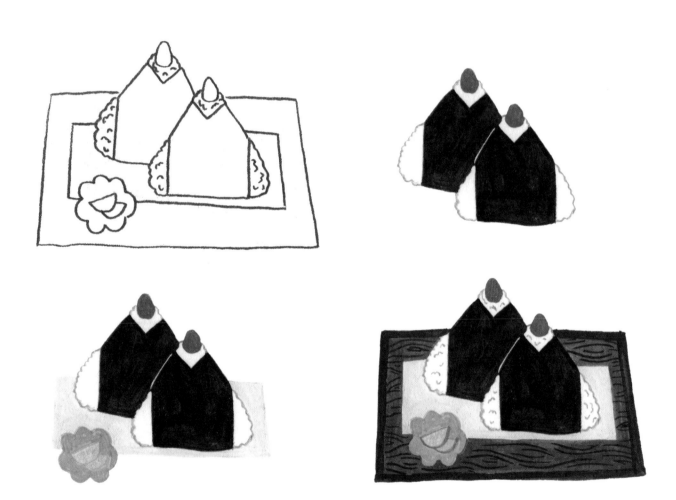

Onigiri (Rice Balls)

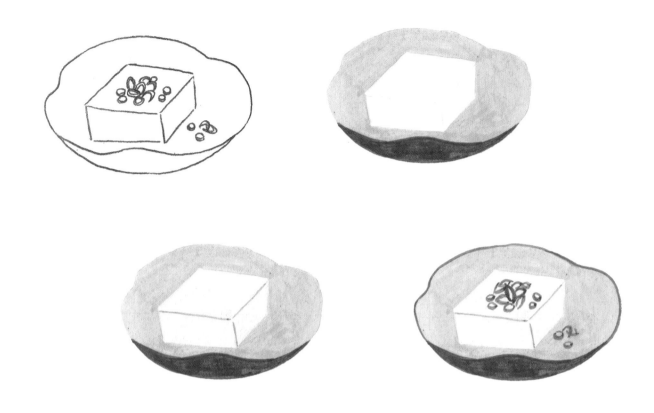

Tofu with Green Onions

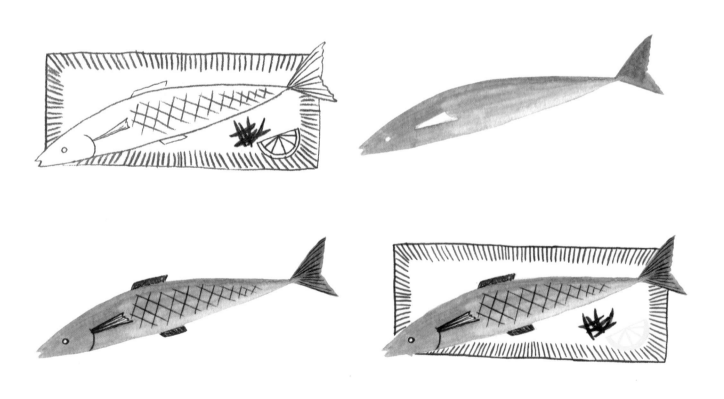

Grilled Fish

Now that you've learned how to draw the elements of a Japanese meal,
let's combine them to draw a complete meal presented on a wooden tray.

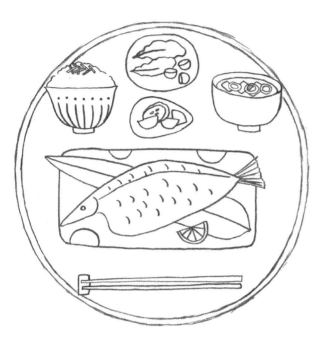

1

Use an HB pencil to create a sketch. I've drawn rice with nori (seaweed), miso soup, grilled fish with lemon on a bamboo leaf, pickles, and a salad, plus chopsticks in the front.

With a light box or window and a mechanical pencil, lightly transfer the sketch to watercolor paper.

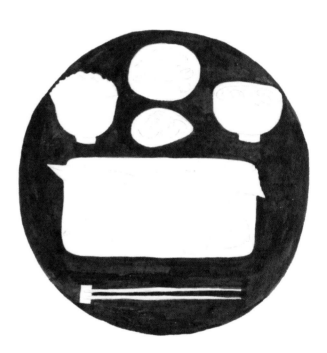

2

With a round brush and brown gouache, fill in the tray. Carefully paint around the dishes, and don't worry if the paint doesn't look completely even—this will give your piece charm and personality!

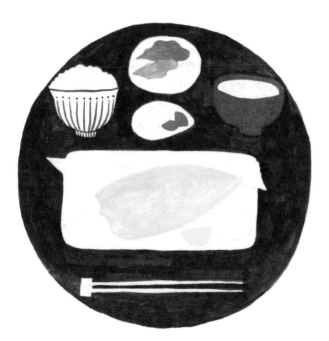

3

Begin adding color to the food.

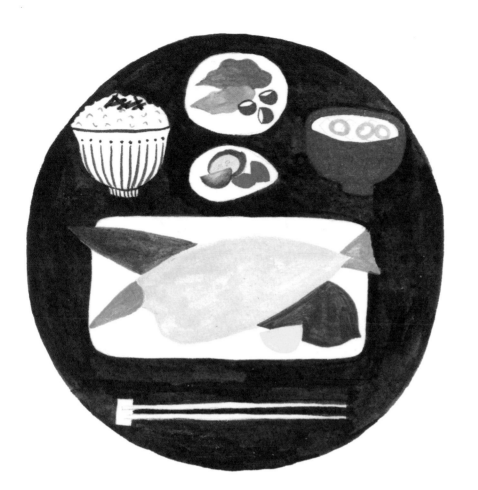

4

Fill in some of the smaller elements in the piece, such as the grains of rice, nori, and bamboo leaf.

5

Add detail to each dish: Define the shape of the fish, paint the chopsticks, and add fine details to the vegetables, soup, and ceramic dishes.

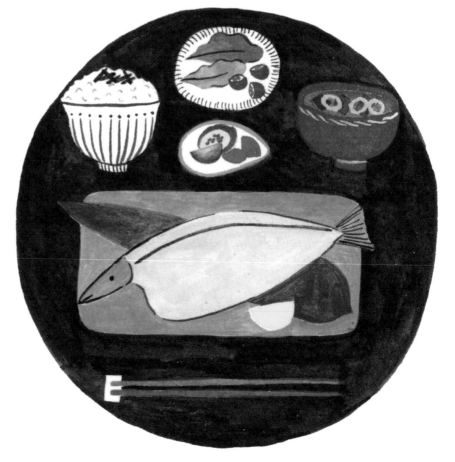

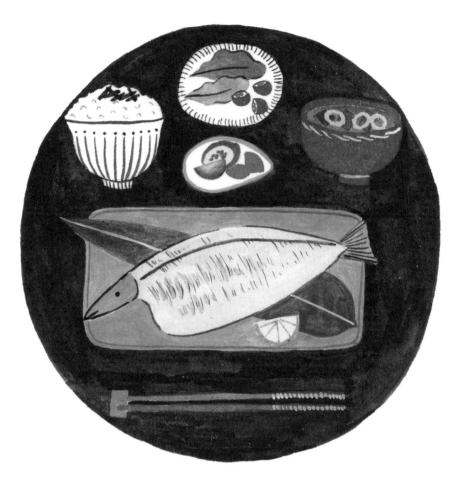

6

With thin strokes and shades of brown, paint grill marks on the fish. Add details to the bamboo leaf, lemon slice, and chopsticks.

7

Lastly, add texture to the wooden tray using a mixture of white and brown gouache and a round brush.

Now you can draw or paint a meal you shared with a loved one and give them the piece of art! This makes a beautiful, personalized way to remember your time together.

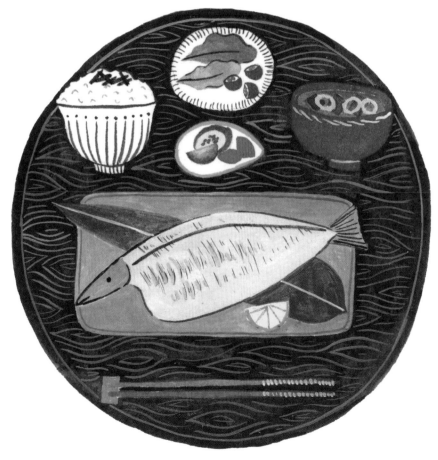

GET OUTSIDE!

This section ventures into the garden and beyond to explore a wide array of outdoor subject matter. You don't need to be far from home to find engaging shapes and objects: Look for small plants growing out of cracks in the wall in your garden, or take a stroll to the local park and make friends with the trees!

GARDENING TOOLS

In this section, the prompts and exercises are designed to get you outside and exploring your own outdoor spaces!

First, let's look at gardening tools, which offer an interesting contrast to the natural items found in the garden—and they're super fun to draw! Follow the warm-up exercise below, focusing on proportions and shapes.

USE A FINELINER PEN FOR THIS PROMPT.

Trowel Start with the handle and add small details, such as the string at the end.

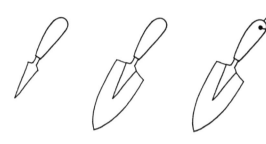

 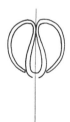 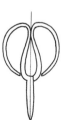

Scissors Use a central line as a guideline to draw well-proportioned scissors.

Flowerpot Start with an oval for the pot's opening; then add the decorative details.

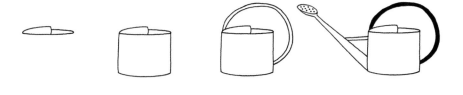

Watering Can Draw the opening at the top, and build on this to add the watering can's other features. Don't forget the dots on the spout!

Using the previous examples as a guide, draw additional tools that can be found in the garden. I've included some ideas below, which I drew using an 02 fineliner pen and a 00 thin brush and black ink.

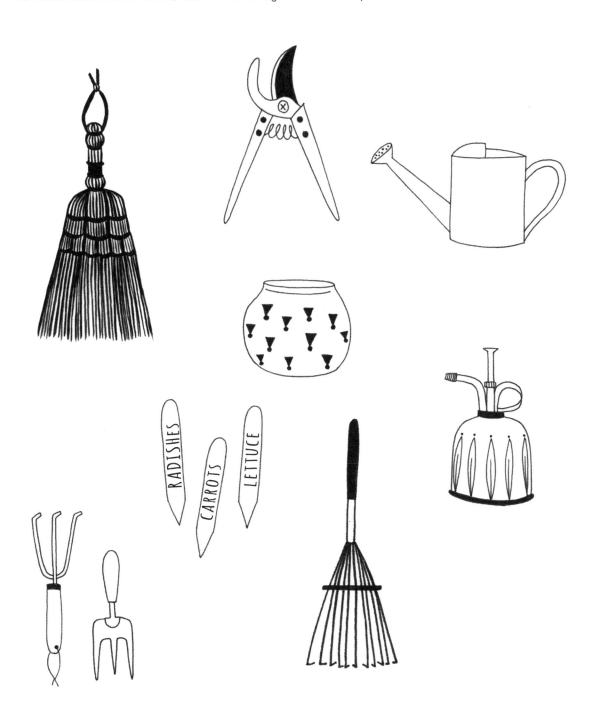

VEGETABLE GARDEN

My own vegetable garden is quite small, but I'm able to grow plenty of herbs and a few pots of lettuce and tomatoes. I especially love sowing seeds and watching them grow up!

This creative prompt looks at popular varieties of vegetables and herbs and encourages you to draw what you grow in your own garden.

USING AN HB PENCIL, PRACTICE THESE SIMPLE SHAPES.

Seedling

Radish

Broccoli

Peas

Basil

Rosemary

Tomatoes

Kale

Lettuce

59

Wooden Planter Box

1

Draw a wooden box, with two panels in the front and soil inside.

2

Add swirly lines on the panels to resemble the patterns seen in pieces of wood.

3

Fill the planter box with your favorite vegetables and herbs!

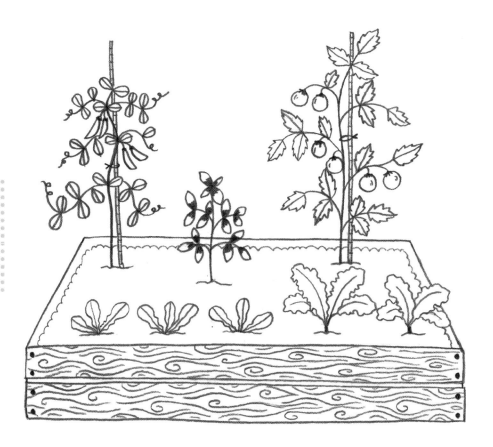

Adding Color

If you have a balcony or small outdoor space, container gardening is a fun way to grow produce. Using colored pencils, draw a colorful vegetable garden filled with interesting pots.

TO ADD INTEREST AND DEPTH, USE TWO SHADES OF GREEN ON A SINGLE PLANT.

DRAW THE STEMS OF ONE PLANT USING TWO COLORS.

TINY PLANTS

Nature can provide great inspiration, but where do you start?
You needn't go far to find things to draw; whether you have a big garden
or a tiny balcony, your own outdoor space will contain lots of shapes and
surprises. You can also venture to a local park, where you may be blown
away by everything you see, if you take your time and look closely.

This exercise will offer lots of inspiration, particularly if you're feeling a little stuck.
Documenting your drawings in a sketchbook gives you great reference material later.

Go outside, and
use black pen or
a pencil to draw
10 tiny plants. Many
interesting shapes
can be found close
to the ground, so
make sure you
crouch down and
look around you.

USING A SINGLE COLOR OR BLACK ALLOWS YOU TO FOCUS ON THE SHAPE AND FORM
OF YOUR SUBJECT, RATHER THAN BEING DISTRACTED BY ITS COLOR AND TEXTURE.

You can use this three-step guide to add color to your plants. I created the plants below using gouache and colored pencil, but any medium will work.

1 Draw the plant's stem or main flower.

2 Fill in the leaves, buds, or flowers.

3 Add details, such as shading, leaf patterns, dots or berries, and fine floral details.

Now let's draw tiny plants featuring fun colors and details. Try using unusual color combinations for the stems and leaves, or add white dots to a dark solid shape. Following the steps on page 63 as a guide, play around with using your favorite colors and art media to add a fun twist to your plants!

Combine the plants to create a pretty pattern. Paint alternating motifs in rows to decorate a handmade greeting card or small gift tag. Also try rotating and flipping the plants as you work on the pattern to create a free-flowing effect. This gives the impression that the plants are dancing around, creating a playful look.

PLAY WITH SCALE WITHIN YOUR PATTERN.
FOR EXAMPLE, YOU CAN COMBINE LARGER MOTIFS WITH TINY LEAVES.

Adding a solid-colored background to your artwork will completely change its look. I love to use acrylic gouache in Prussian blue; this is my go-to background color, as it makes almost any other color "pop" next to it.

1 Draw a box and sketch plants inside.

2 Fill in the background with color, painting around the shapes. The stems can be painted over.

3 Paint the plants' stems.

 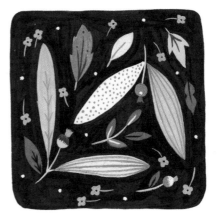

4 Add color to some of the leaves and flowers.

5 Add details. Play around with adding lines and dots on the leaves.

6 Add background elements—such as floating flowers, dots, and additional leaves—to fill in the gaps in your artwork and balance it out.

ACRYLIC GOUACHE IS THE PERFECT BASE LAYER FOR ADDING DETAILS ON TOP, AS IT DOESN'T BUDGE AFTER DRYING, EVEN WITH ADDED WATER.

LOCAL PARK

I enjoy spending quiet time at my local park, sitting under my favorite tree and having a picnic or just watching the world go by. Visiting a park can provide you with interesting and unusual subject matter for drawing, plus it gets you out and about!

The following pages feature examples of what you might find in a park, as well as step-by-step drawing instructions. Using the same techniques, practice with a few objects you see in your own local park.

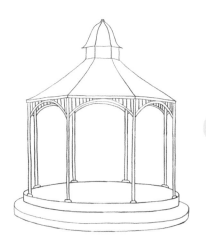

1 Use a 0.5mm HB mechanical pencil to sketch a gazebo. With a light box, transfer the sketch onto watercolor paper. Prepare some black gouache paint, and grab a size 0 paintbrush.

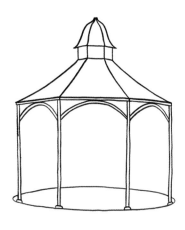

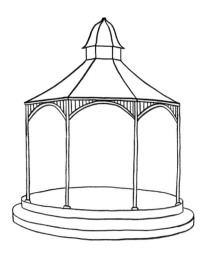

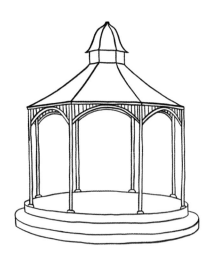

2 Working directly on the light box, paint the gazebo's roof and front poles.

3 Add the gazebo's steps, as well as details to the arches.

4 Complete the gazebo by filling in the poles in the back to create perspective.

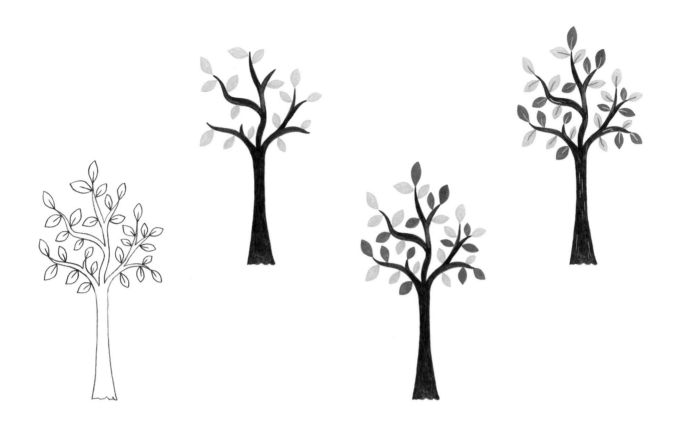

This simple tree features bright green leaves. Start with the trunk; then add branches that taper at the ends, as well as smaller branches from the sides. Decorate the branches with leaves and add veins to the leaves.

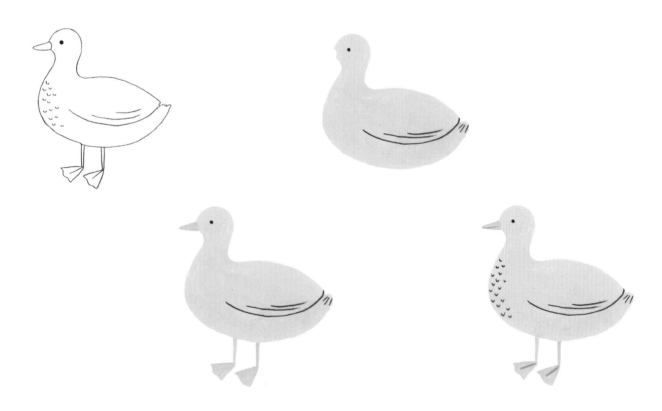

When drawing a duck, remember to make the chest round and puffed out, and add webbed feet. Its beak should be long and full. Add little "U" shapes to the chest in a contrasting color to show feather details.

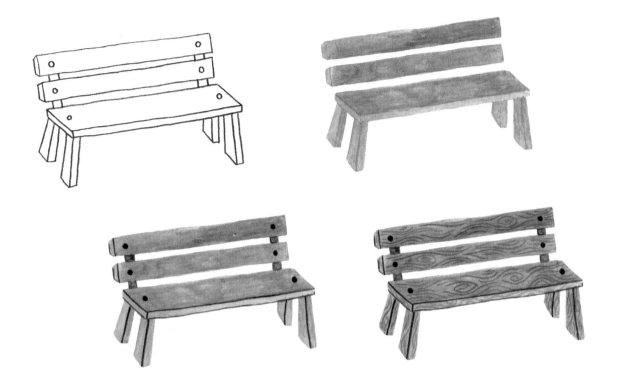

Keep this park bench simple: Draw two planks of wood in the back and a single large plank for the seat.
Add details in a darker tone; then create swirling lines to show a wood pattern.

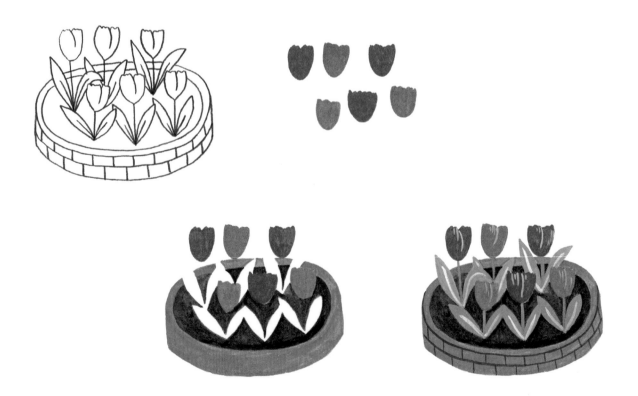

Create a small flower bed of tulips by painting the flowers first,
and then work on the soil and brick detailing around the flowers.

Now bring all the elements together to create a scene from your local park using black gouache and a fine-tipped brush.

When painting a scene using only one color, add texture, such as the dashed lines on the path and the pattern on the tree trunks. Fill in some areas with solid color. This creates harmony in the scene and gives the viewer's eyes focal points around the artwork.

Small lines in the lake and near the ducks create the impression of movement in the water. These can also be added around leaves and flowers to show them swaying in the wind.

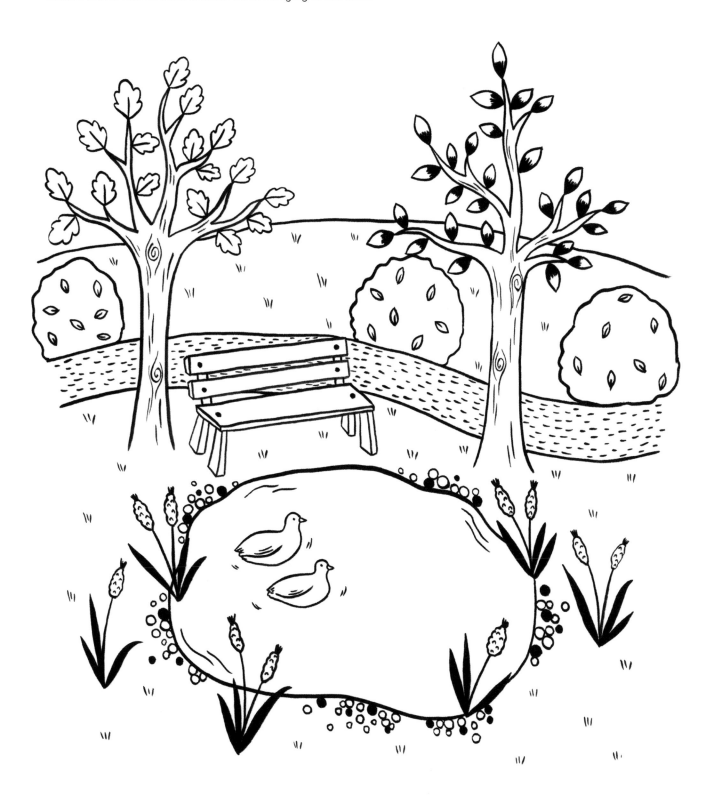

INSECTS

Insects make wonderful drawing subjects, as they feature relatively simple shapes that allow you to have fun using lines, dots, and other patterns. Some insects aren't naturally colorful, but you can still apply bright colors to their basic shapes.

USE A 0.5MM HB MECHANICAL PENCIL TO SKETCH A VARIETY OF INSECTS; THEN TRANSFER THE SKETCHES TO WATERCOLOR PAPER USING A LIGHT BOX OR WINDOW. ADD COLOR WITH GOUACHE AND A FINE-TIPPED BRUSH.

Moth

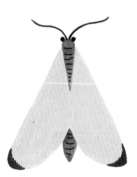

1 Draw the basic shape of a moth; then add detail.

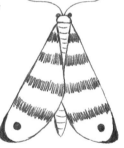

2 Paint the wings.

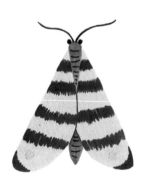

3 Add the body, eyes, and antennae.

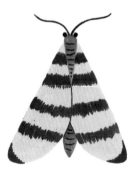

4 Using a darker color than the one for the body, paint lines to create texture on the moth's body. Also color in the tips of the wings.

5 With the tip of your paintbrush and a small amount of paint, create thin strokes to add stripes on the moth's wings.

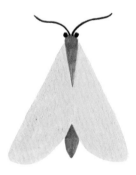

6 Use a contrasting color to add dots at the bottom of each wing.

Beetles

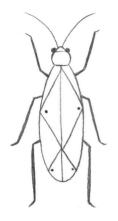 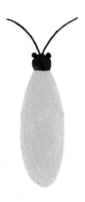 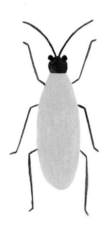 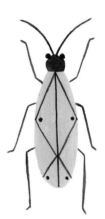

When drawing a beetle, you can really have fun with the body shape, pattern, and color combinations. First paint the body and head; then add details.

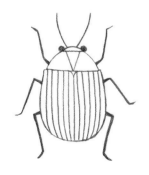 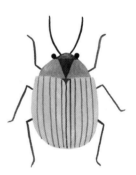

This round beetle features a decorated head and a striped body.
To create a harmonious balance of colors, match the details in the head to the beetle's legs.
Use the tip of your brush to add the stripes on the body last.

Butterfly

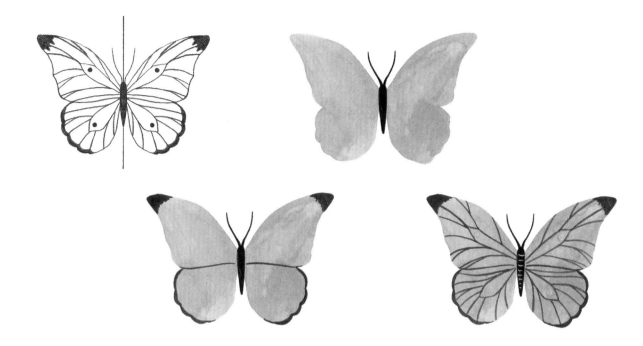

To create a butterfly, I like to draw one vertical half of the butterfly first, and then I add the mirror image on the other side. Creating a vertical line down the middle makes this easier. After transferring the sketch, add color to both wings before drawing details, such as lines and dots.

Snail

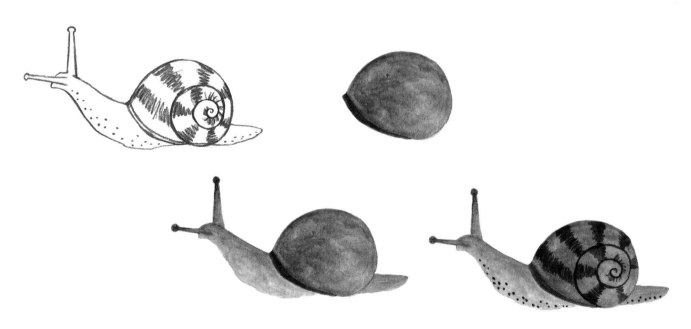

When drawing a snail, make sure the body sits snugly by the shell, with a small portion of the tail poking out. Finish by adding tiny dots on the snail's body to create interest and texture.

Floral-Decorated Moth

I like playing around with adding floral designs to insects. The flowers growing outward on this moth's body give it a joyful look, and you can really use your imagination with the placement and shapes of the flowers and leaves.

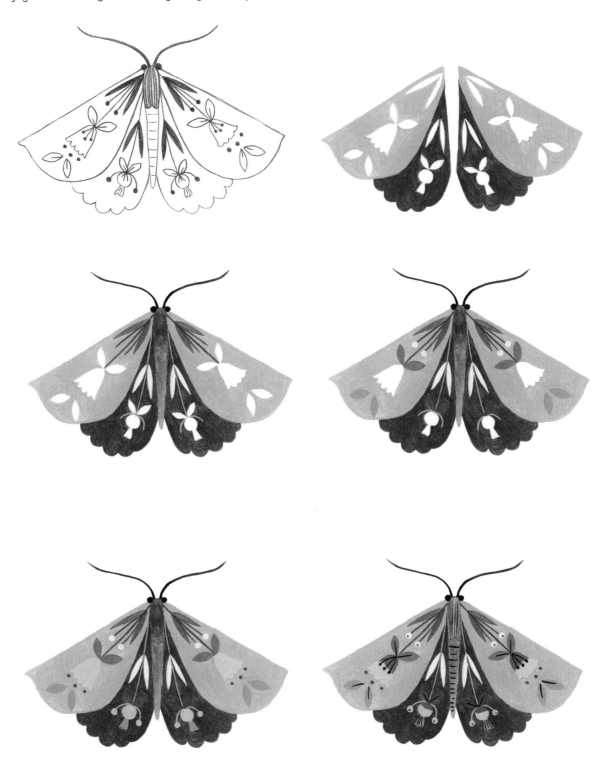

First, draw the outline of the moth; then, working from the body in the middle, bring out the stems and leaves before placing flowers and berries at the end. Add additional leaves and dots if you notice any gaps; these detail elements bring together the design.

EVERYDAY LIFE

Many of the functional objects you use every day can be turned into perfect drawing subjects. No matter where you work or spend your time, there will be an abundance of objects within easy reach, just waiting for you to pick them up and study. This section explores some of these common items and encourages you to take a closer look at your everyday life.

PENCIL CASE

As a child, one of the things I loved most about starting a new school year was organizing my pencil case. I've always been obsessed with stationery, and I'd spend hours choosing new pencils, pens, and erasers. Selecting a pencil case to house them all in was a very important part of the process!

USE A NIB PEN AND A BOTTLE OF BLACK INK TO DRAW THE CONTENTS OF YOUR PENCIL CASE.

Outline the pencil case.

Add a vertical line down one side and a zipper at the bottom; then draw elastic holders for the contents as shown.

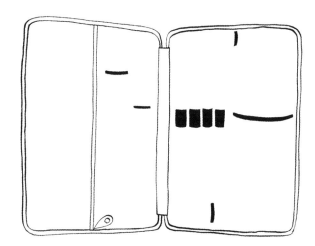

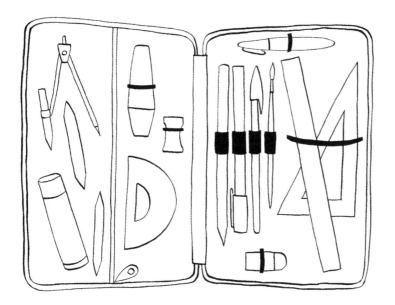

Outline the contents of the pencil case, fitting the pens and pencils into the smaller elastic holders and the bigger items, such as the rulers, into the larger holders.

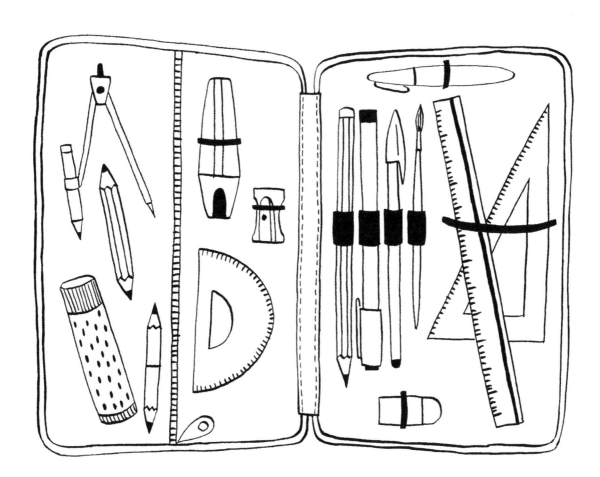

Add details to the items in the pencil case, such as lines on the pencils, stitching down the center of the case, and a pattern on the glue stick.

THE SLIGHTLY UNEVEN LINES ARE TYPICAL OF THIS TECHNIQUE
AND ADD CHARM TO THE FINAL PIECE.

LAMPS

Floor lamps, table lamps, vintage, modern, small, large, decorative, minimalistic...
There are so many lamps to choose from! What lamps do you have in your home?
Let's sketch them using a size 00 brush and black gouache paint.
This method creates natural-looking drawings with interesting results; simply
let the brush flow where you want to create fluid lines and decorative details.

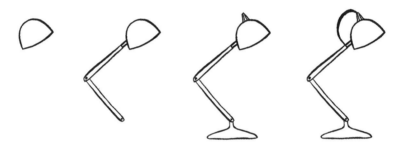

Desk Lamp Begin with the dome-shaped shade; then add the stand and base.

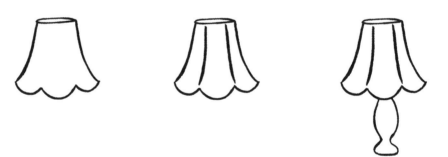

Scalloped Lampshade Draw an oval as your starting point and then work down, adding detail to the shade and base.

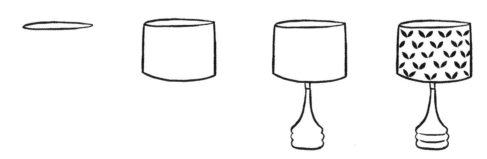

Patterned Lampshade Start with an oval, and then draw the shade. Add a pattern and details to the base.

78

Hanging Pendant Lamp Draw the round bulb and work up, adding the hanging cord and then the filament inside the light bulb.

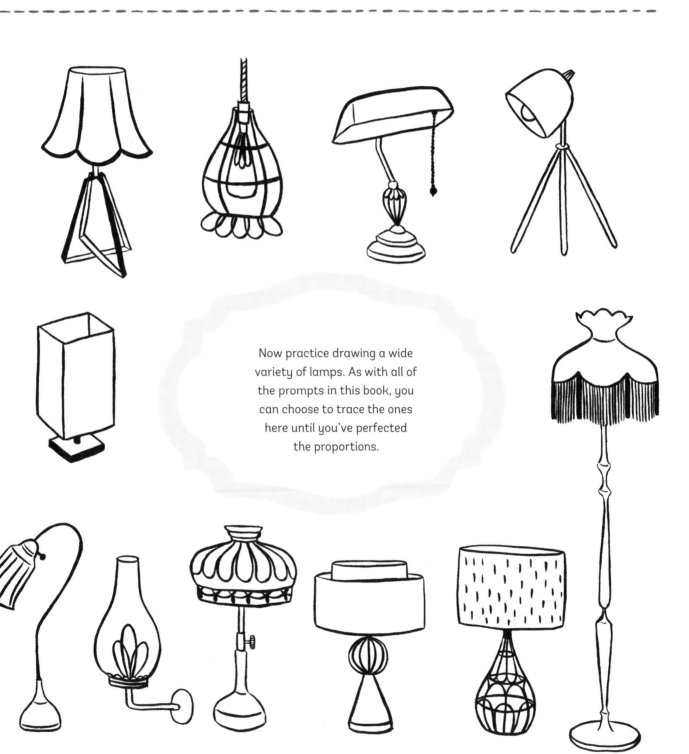

Now practice drawing a wide variety of lamps. As with all of the prompts in this book, you can choose to trace the ones here until you've perfected the proportions.

DESK

Many of us spend the majority of the day working at a desk;
why not look there for inspiration for your next drawing exercise?

1

Do a quick sketch of your desk using an HB mechanical pencil, balancing the objects around the sketch to avoid a busy look. Plants add contrast to the man-made items, and a rug underneath the desk grounds the design and offers an opportunity for a large splash of color.

Then transfer the sketch onto watercolor paper using a light box or a window.

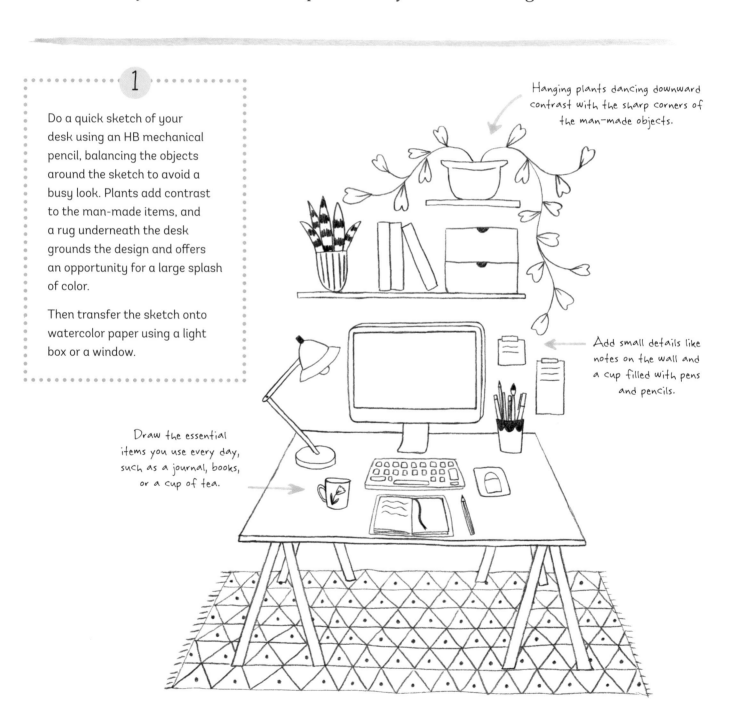

Hanging plants dancing downward contrast with the sharp corners of the man-made objects.

Add small details like notes on the wall and a cup filled with pens and pencils.

Draw the essential items you use every day, such as a journal, books, or a cup of tea.

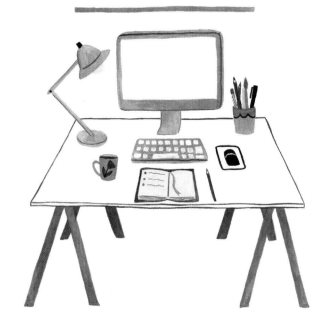

2

Working on watercolor paper, paint the legs of the desk and the shelves above using gouache.

3

Add objects on the desk, taking the time to add details, such as the pattern on the mug and colorful pens in the cup. Use the tip of your paintbrush to paint the outline of the desk.

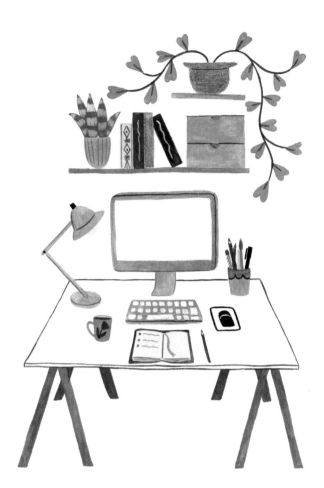

4

Fill in the objects on the shelves. Have fun with the plants: Mix up the colors of the stems and leaves, and use colored pencils for the plant pot!

5

With the main elements in place, give the computer a screen saver, such as this gentle leaf pattern. Don't forget to add details to the notes on the wall!

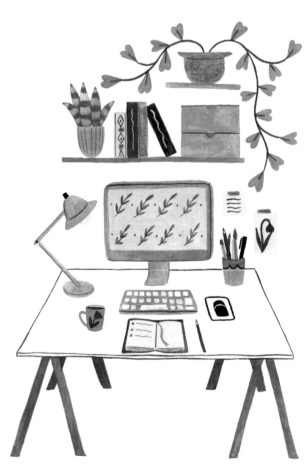

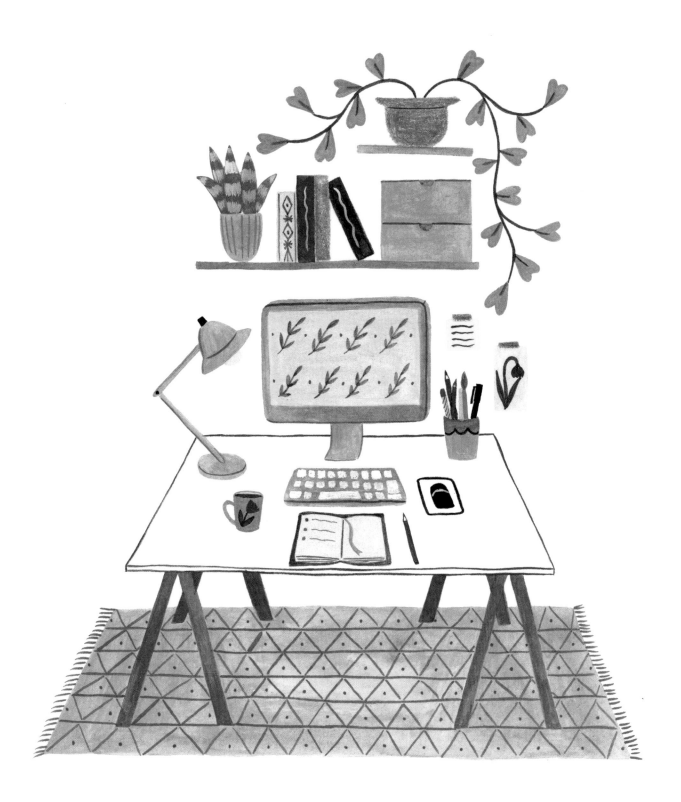

6

Lastly, add the rug, carefully painting around the desk legs. Using a darker tone, add lines, dots, and tassels to tie everything together.

OFFICE SUPPLIES

Look around your desk at work or at home, and you're bound to find plenty of interesting shapes just waiting to be drawn. What's hiding in your drawers or on your shelves? Draw objects you normally wouldn't, such as a stapler or a pair of scissors.

FIRST, FIGURE OUT THE SHAPES USING AN HB PENCIL. THEN DRAW THE ITEMS AGAIN, ADDING COLOR THIS TIME.

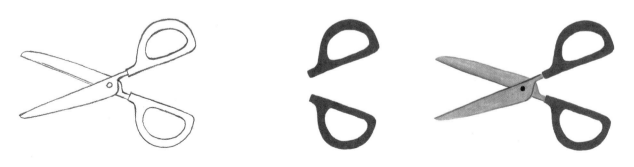

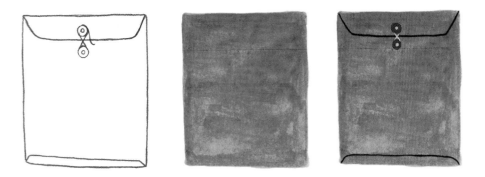

Now, let's build on those drawings and create a whole collection of office supplies. This work would make a sweet piece of art to hang in your own office!

1

With an HB pencil, sketch your objects onto a sheet of printer paper. Then, using a light box or window, lightly trace your design onto watercolor paper.

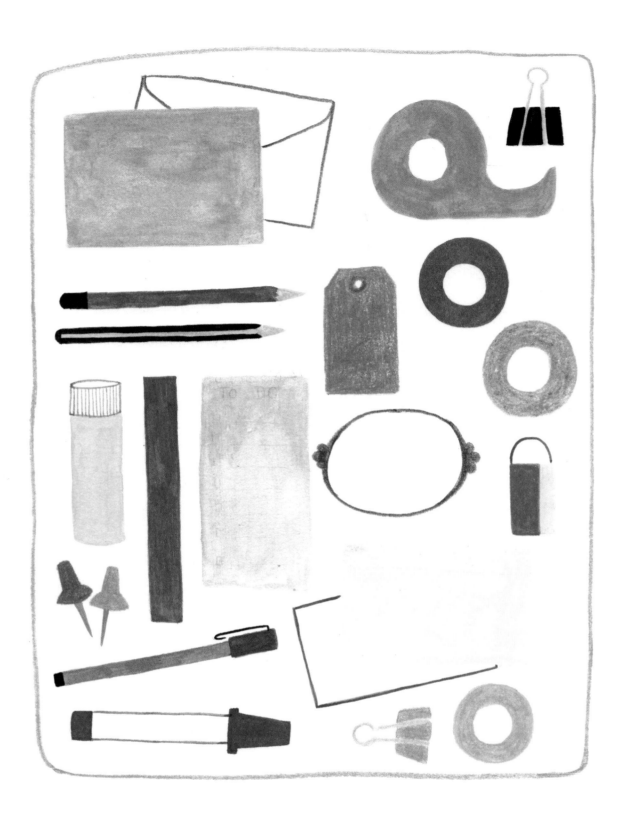

2

Using gouache paint and colored pencils, add flat color to the objects, and draw a rectangular frame around them.

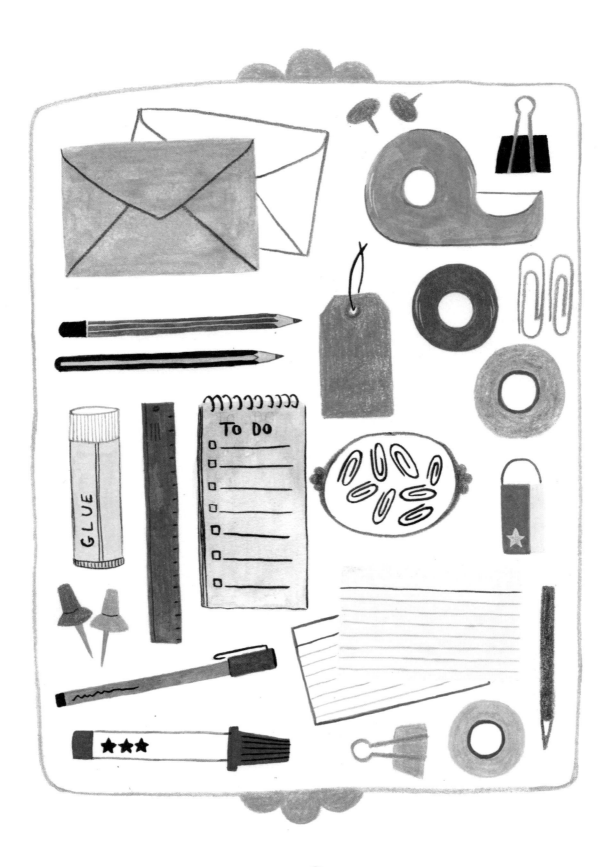

3

Use a size 00 brush or a very sharp colored pencil to add fine details to each object. Add decorative elements to the frame, and you've created a fun piece of art to hang on the wall!

SEWING MACHINE

I grew up sewing with my mother and grandmother—it's still one of my favorite things to do when I'm not illustrating. My mother owned a vintage sewing machine with a foot pedal, and it's always struck me as more aesthetically pleasing than the modern electric kind!

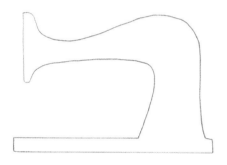

1

Sketch the outline of a sewing machine using an HB pencil.

2

Add the spool of thread, the handwheel, and the needle. Also draw a line of thread from the spool to the needle.

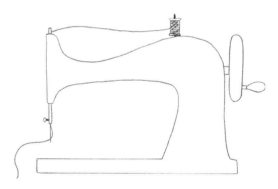

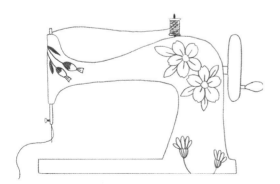

3

Now you can add decorative elements to the body of the sewing machine. Draw flowers, leaves, and smaller blooms.

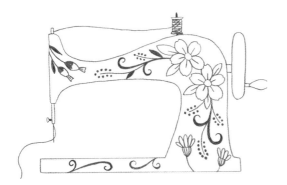

4

Add swirls and smaller plants with dots and berries.

THE CONTRAST OF LARGE BLOOMS PAIRED WITH SMALLER DETAILS BALANCES THE FINAL PIECE AND ALLOWS THE VIEWER'S EYE TO EASILY MOVE AROUND THE ARTWORK AND ENJOY EVERY ELEMENT.

5

Use a light box or window and a 0.3mm HB pencil to lightly transfer your design onto watercolor paper. There's no need to include the swirly lines or plant stalks; they will be added later using your original sketch as a reference.

Then paint the sewing machine using black acrylic gouache, carefully painting around the flowers.

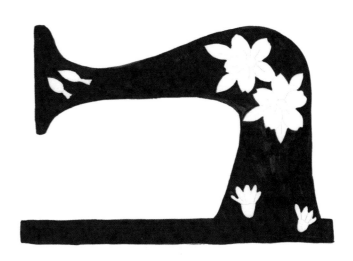

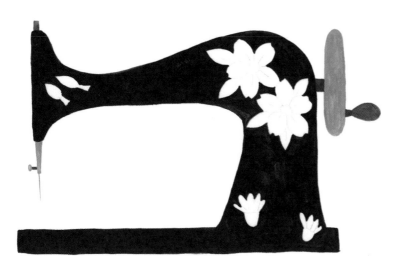

6

Add color to the handwheel and needle.

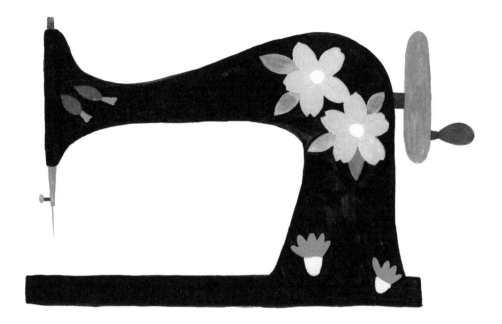

7

Paint the flowers.

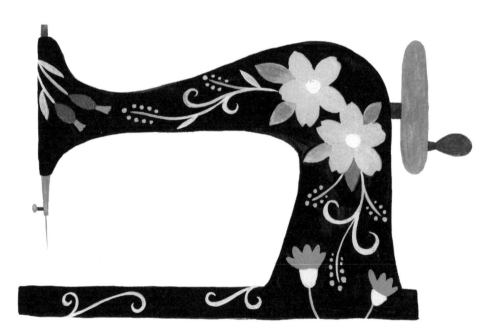

8

Using your sketch as a reference, paint swirly lines, small dots, stems, and leaves on top of the now-dry black paint. Because acrylic gouache isn't water-soluble once dry, painting on top of it won't cause smudging, which allows you to paint clean lines using a lighter color without the risk of murky paint colors.

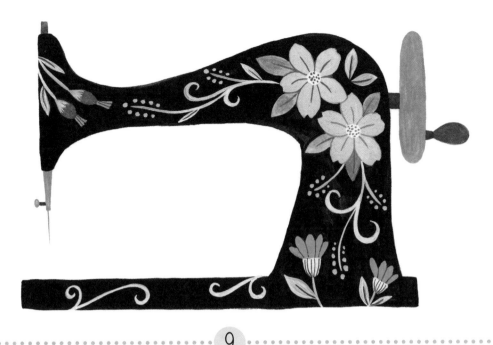

○ 9 ○

This is my favorite part! Refine the design by adding small details to the flowers and leaves with a size 0 brush. Add leaves to fill in any open spaces on the sewing machine.

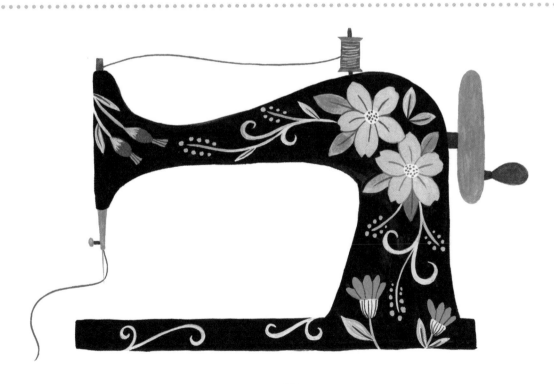

○ 10 ○

Lastly, add the spool of thread on top of the machine and bring the thread down through the needle. Save this step until the end so that you can choose the color that best suits your design!

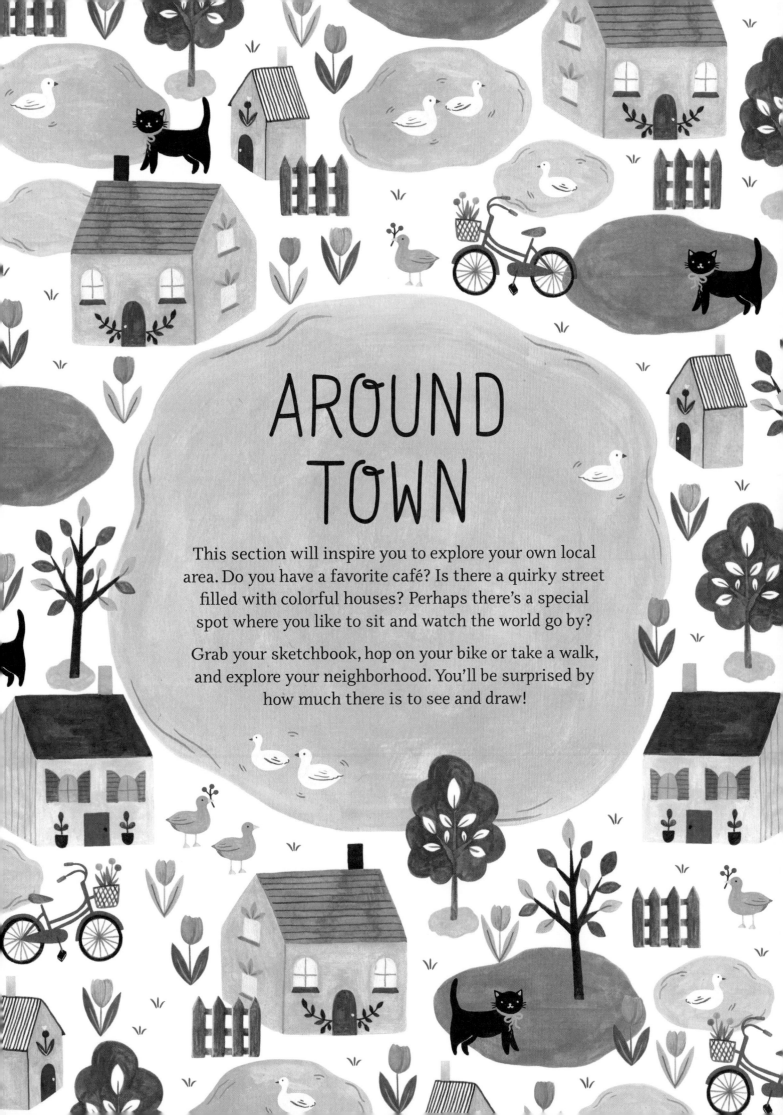

AROUND TOWN

This section will inspire you to explore your own local area. Do you have a favorite café? Is there a quirky street filled with colorful houses? Perhaps there's a special spot where you like to sit and watch the world go by?

Grab your sketchbook, hop on your bike or take a walk, and explore your neighborhood. You'll be surprised by how much there is to see and draw!

BICYCLE

When drawing a bicycle, it can be difficult to get the proportions and alignment right. Here, I've included a simple, easy-to-follow tutorial for drawing a bike using my own two-wheeler that I ride around town. Soon you'll be drawing bicycles with ease!

I USED A 0.5MM HB MECHANICAL PENCIL AND A STICK ERASER TO REMOVE AND REDRAW AREAS OF DETAIL.

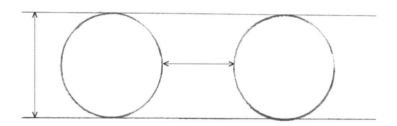

Use a ruler to lightly draw two horizontal lines a couple inches apart; then draw two circles inside the lines.

Draw the basic frame of the bicycle, as shown here.

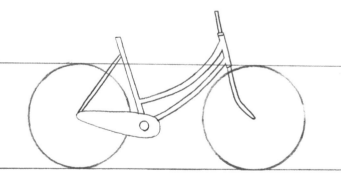

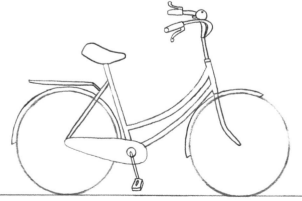

Add handlebars, a seat, a pedal, and other elements to the bike. Once you have the basic shape of the bicycle down, you can add details and erase the upper guideline.

Thicken the tires with shading and add a basket to the front of the bike.

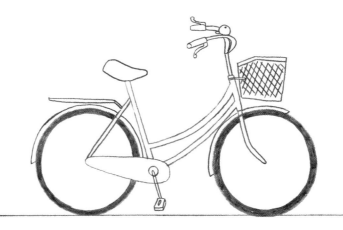

To bring the bike to life, create shading on the bicycle seat and handlebars. Add spokes to the wheels and erase the bottom guideline to finish your drawing.

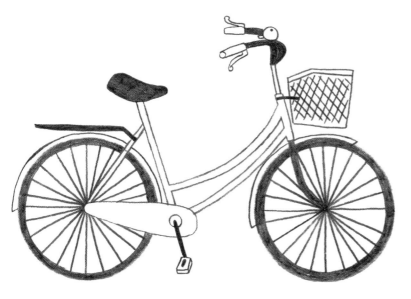

THE PROCESS OF DRAWING A SCOOTER IS VERY SIMILAR TO DRAWING A BICYCLE: START WITH THE WHEELS, THEN DRAW THE FRAME, AND ADD THE DETAILS LAST.

MAILBOXES

Have you ever paid attention to the different mailboxes around your neighborhood? Mailboxes tend to be small, which makes them excellent drawing subjects with which to practice, and they can be varied, unique, pretty, and exquisite! Even an ornate mail slot in a door can be eye-catching and charming.

I USED A NIB PEN AND BLACK INK HERE TO CREATE LOOSE, FLUID LINES.

 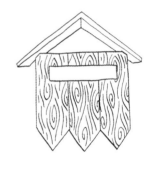

| With a ruler and pencil, draw a vertical guideline. Keeping the guideline in the center and using black ink and a nib pen, draw a box with three points at the bottom. | Draw a roof on top using the vertical guideline as its center. Now it's starting to resemble a little house! | Add a rectangular opening for the mail slot, plus vertical lines inside the box. Erase the guideline. | Lastly, add some vertical swirly lines to create a wooden effect, making sure to draw around the mail slot. |

To draw a mail slot, start with a rectangle before adding a decorative shape around it. Don't worry if it's not perfect—it adds to the charm! Hand letter a word inside the rectangle, such as "letters" or "mail."

To draw an ornately patterned mailbox, start with a curved arch. This will form the top of the mailbox.

Add a set of vertical lines on each side and horizontal lines at the bottom to create a box.

Draw a rectangle with a lip at the bottom; then add a larger box underneath.

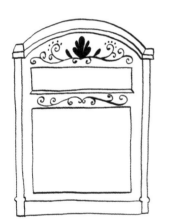

Add ornate details.

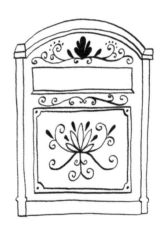

Add a pretty floral motif and smaller frame inside the larger box.

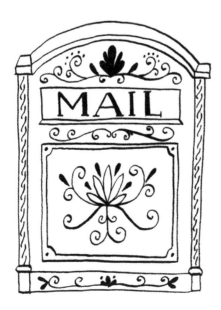

Finally, hand letter the word "MAIL" inside the rectangle and add detail to the columns on each side of the mailbox.

HOUSE

Anytime I'm feeling uninspired or like I need to get out of the house, I take a short stroll around my neighborhood. Often, I'll come across charming houses that make for wonderful subject matter, like this townhouse. When I see something I like, I'll take a photo and save it to a specific album on my phone for future reference. What do the houses look like in your neighborhood?

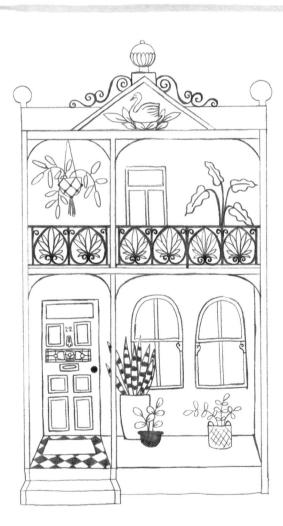

1

With a mechanical pencil, create a sketch of a home in your neighborhood, or draw this one. Capture as much detail as you wish. Place the sketch on a light box and secure with masking tape; then place a sheet of watercolor paper on top and secure that with masking tape as well.

In a palette, mix black gouache with a small amount of water. You will want to create a flat, dark line, so the gouache should remain opaque.

IF YOU DON'T HAVE A LIGHT BOX, YOU MAY PAINT OVER YOUR SKETCH.

2

With the sketch showing through the light box, paint directly onto the watercolor paper using a round brush and the prepared black gouache mixture. Start with the main lines of the house. Even with a very steady hand, this technique won't create a perfectly straight line, so you'll end up with a beautifully organic, hand-drawn look.

3

Paint the remaining lines of the house, including any features on the roof, steps leading up to the front door, and so on.

4

Draw the front door and add any decorative details to the house, such as a wrought-iron balcony and swirls on the roof.

5

Add smaller details, like plants on the front porch, a doormat, decorations in the wrought-iron balcony, and an artistic motif on the roof.

6

Fill in the windows, front door details, and plants on the balcony.

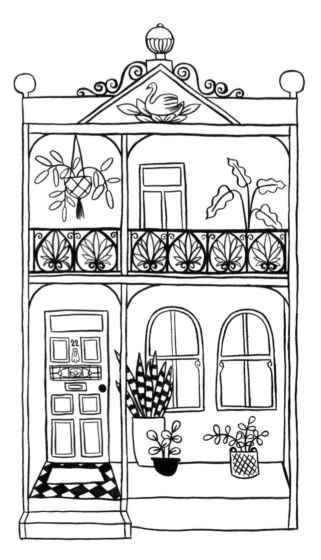

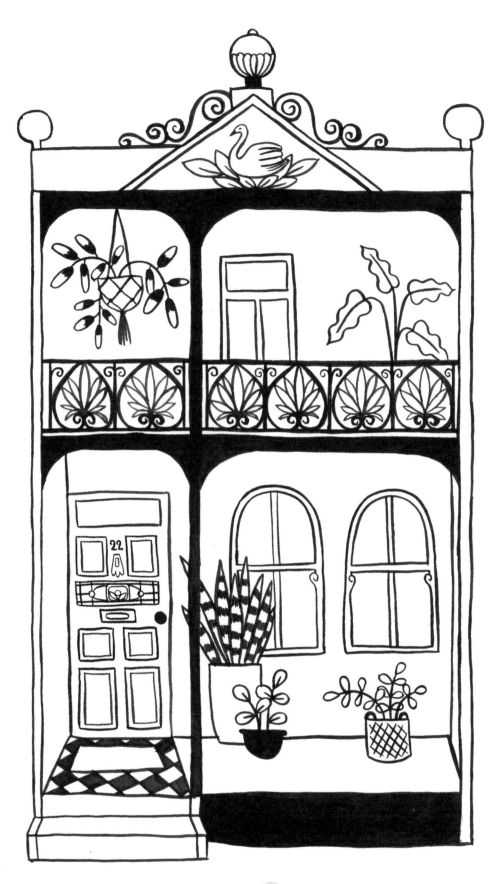

7

To break up the little details and create harmony in your final piece, fill in some solid areas in your artwork. The main horizontal and vertical lines can be filled in, as can some of the plants.

CAFÉ

Every Monday morning, I visit my local café and spend a couple of hours planning out my week. This gets me out of my usual workspace and into a different environment where I feel stimulated and productive. Wherever you work from, this is a great habit to form; I always leave feeling organized and ready to tackle my to-do list. Cafés can also be calming places—somewhere to relax, enjoy the atmosphere, and marvel at the décor.

WHAT DOES YOUR FAVORITE CAFÉ LOOK LIKE? LET'S DRAW IT USING COLORED PENCILS AND GOUACHE PAINT.

1

Use a colored pencil to draw an arch.

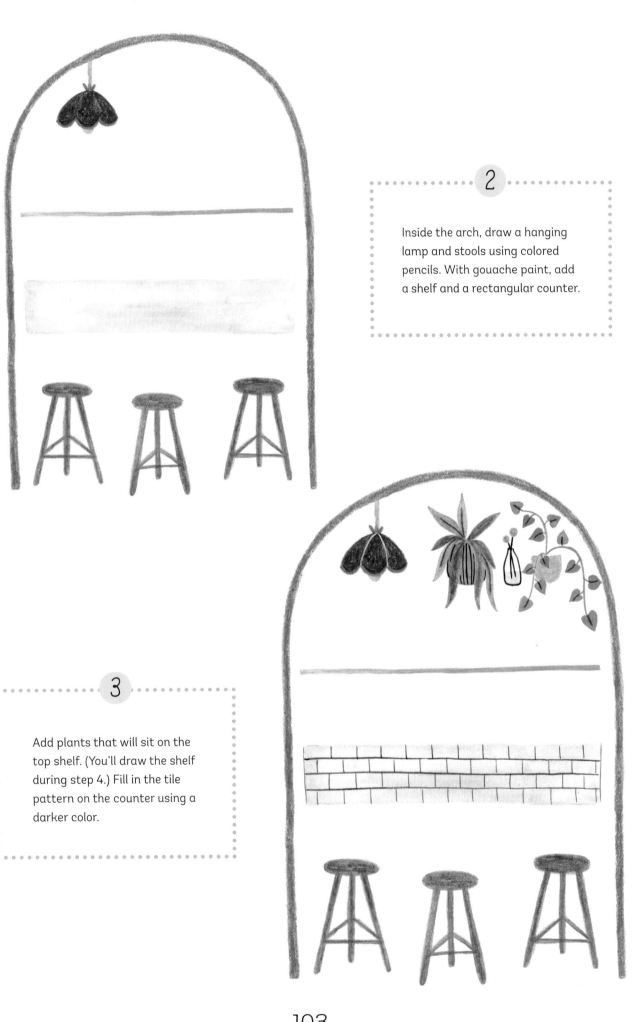

2

Inside the arch, draw a hanging lamp and stools using colored pencils. With gouache paint, add a shelf and a rectangular counter.

3

Add plants that will sit on the top shelf. (You'll draw the shelf during step 4.) Fill in the tile pattern on the counter using a darker color.

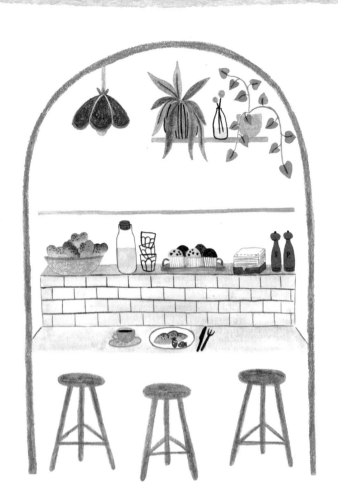

4

Draw the items on the counter, such as muffins, rolls, water, napkins, and salt and pepper shakers. Next, add your own snack, along with a cup of coffee or tea (whatever you prefer!), and fill in the rest of the counter around the art.

5

Fill in the items on the middle shelf using both colored pencils and gouache. Alternating media creates a lovely textural contrast!

Draw the rest of the tile pattern and wall behind the stools, and add hanging plants and a menu on the wall outside the café.

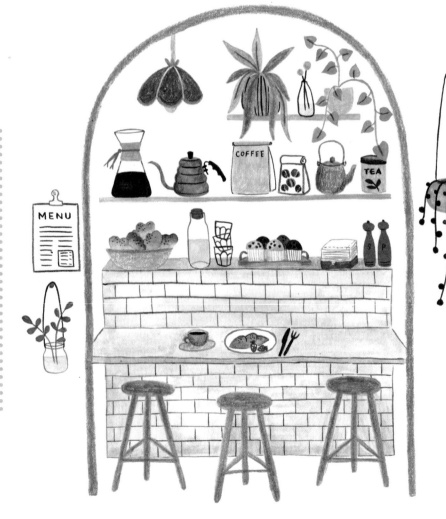

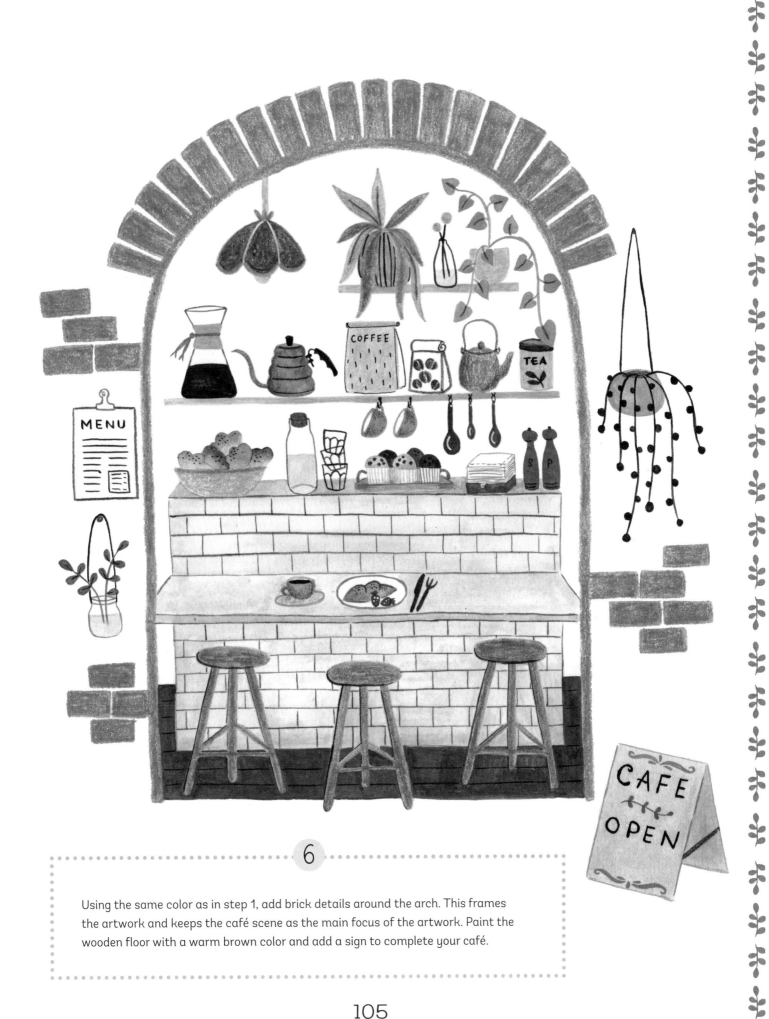

6

Using the same color as in step 1, add brick details around the arch. This frames the artwork and keeps the café scene as the main focus of the artwork. Paint the wooden floor with a warm brown color and add a sign to complete your café.

NEIGHBORHOOD MAP

This exercise takes you through the steps of creating a map of your own neighborhood. Before you begin, take a walk around your local area and write down any special stores, cafés, and landmarks you may want to include.

Once you have a list of locations, practice creating small icons of your favorite places. A teapot and teacup can represent a café, potted plants signify a nursery, and so on. I used black gouache and a fine-tipped brush to paint the ideas below. Be as detailed as you like, or keep your icons simple and clean. Just make sure they're recognizable!

Café

Neighborhood

Nursery

Parks & Gardens

Train Station

Farmers Market

1

Use gouache to paint the streets of your neighborhood. You can refer to a map or make a sketch before adding paint if you wish. There's no need to include every single street; keep it simple by focusing on the major roads so you have more space to illustrate your icons.

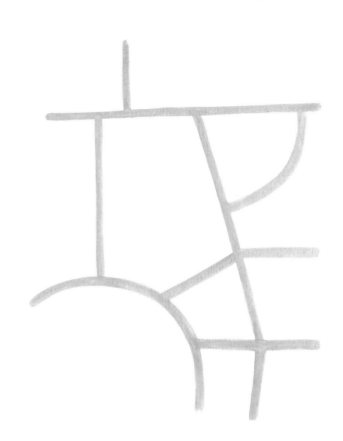

I LIKE TO USE A NEUTRAL COLOR LIKE GRAY FOR THE STREETS SO THAT THE MORE COLORFUL ICONS WILL STAND OUT.

2

Add trees and parks to the map. I live near a botanical garden with a lake, which I've added to my map, along with a bird that I will paint during the next step.

3

Fill in the buildings. I added houses, a library, and a train station with the train tracks behind it.

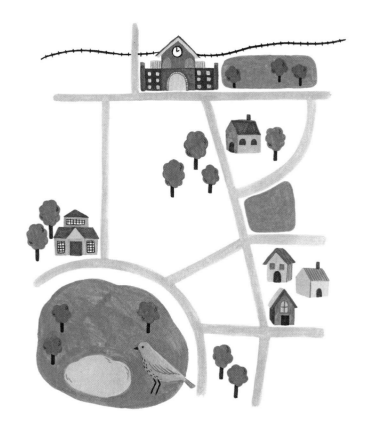

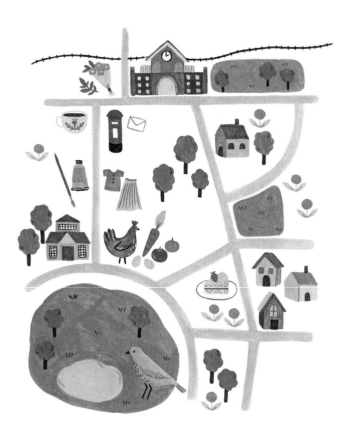

4

Add the rest of your icons throughout the map, such as a café, farmers market, and post office. Keep the spacing balanced so that there are no obvious gaps on the map.

Then add grass and flowers around the map to instantly make your neighborhood look cheerful and pretty!

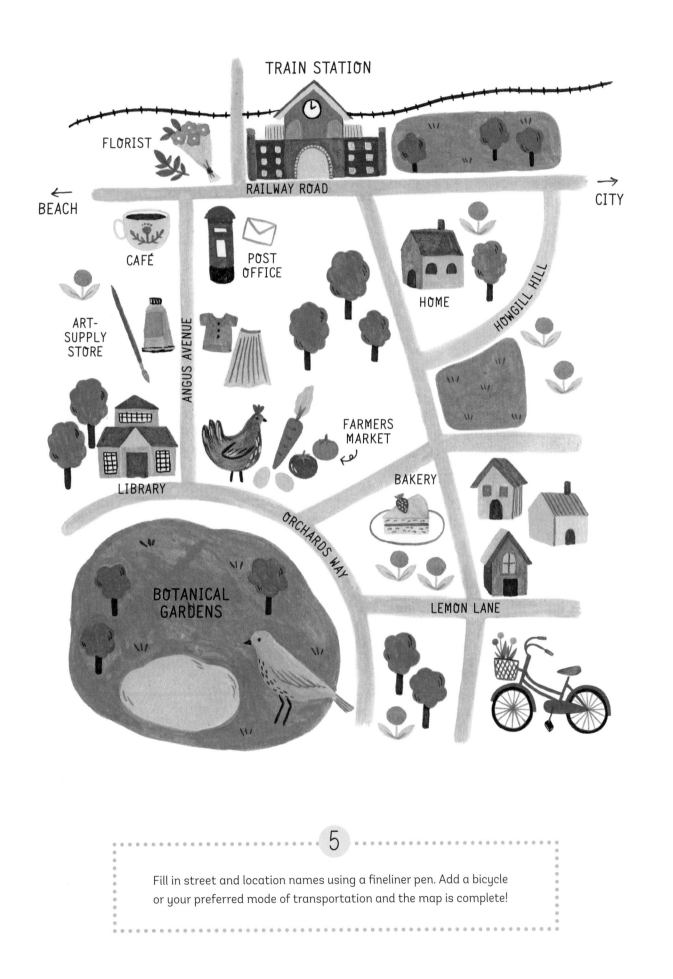

TRAIN STATION

FLORIST

BEACH

RAILWAY ROAD

CITY

CAFÉ

POST OFFICE

HOME

HOWGILL HILL

ART-SUPPLY STORE

ANGUS AVENUE

FARMERS MARKET

LIBRARY

BAKERY

ORCHARDS WAY

BOTANICAL GARDENS

LEMON LANE

5

Fill in street and location names using a fineliner pen. Add a bicycle
or your preferred mode of transportation and the map is complete!

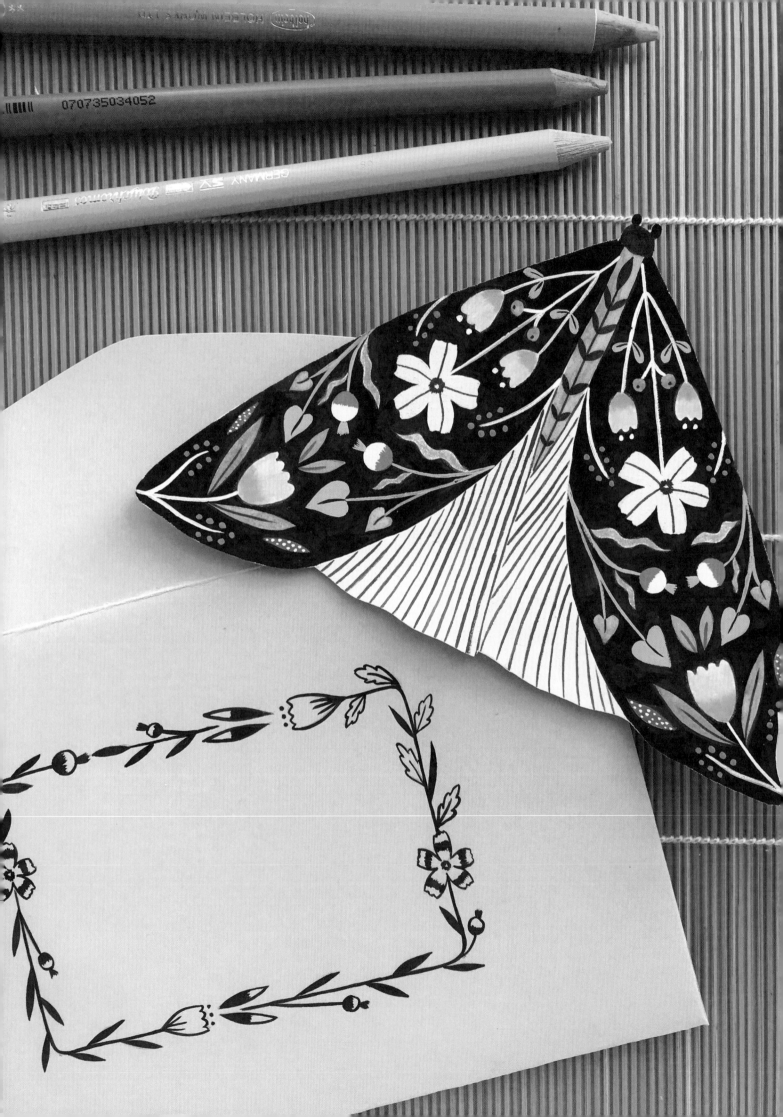

CRAFTING PROJECTS

CONCERTINA BOOK

This little concertina book is a terrific way to store visual memories of the plants you encounter. Whether you include something you saw on a walk in the forest or while relaxing in your garden, your concertina book will become a special keepsake to treasure or gift to a loved one.

Tools & Materials:

- 20" x 3" sheet of white card stock (200gsm)
- Bone folder tool
- Double-sided tape
- 2 sheets of 2½" x 3" colored paper
- 2 pieces of 12" twine or thin ribbon
- Color media of your choice, such as gouache and colored pencils

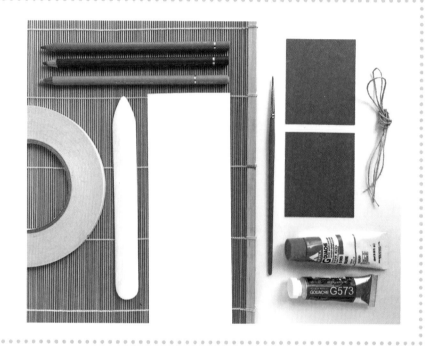

1. Fold the white card stock in half and use the bone folder tool to make a neat, crisp crease.

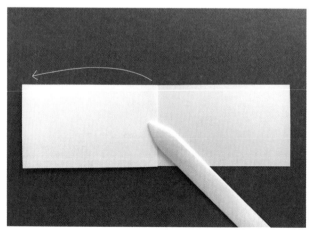

2. Fold the paper in half again.

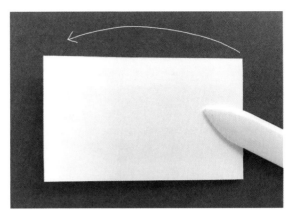

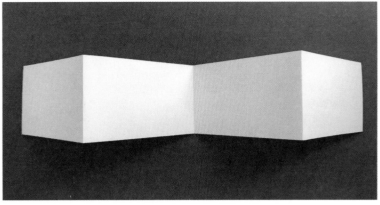

3 Flip the paper over and make another fold.

4 Unfold the paper to display four separate panels.

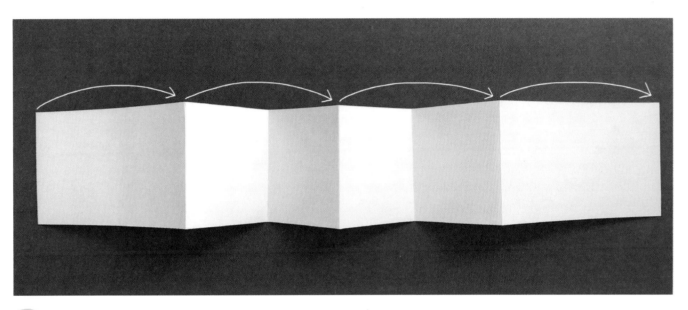

5 Fold each panel in half one by one to double the number of panels. Use the arrows in this photo as a guide.

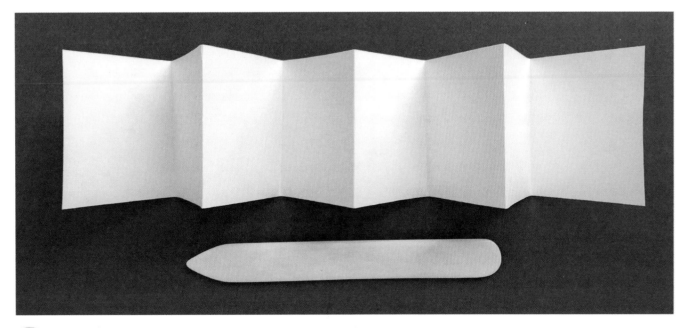

6 Now your folds are complete!

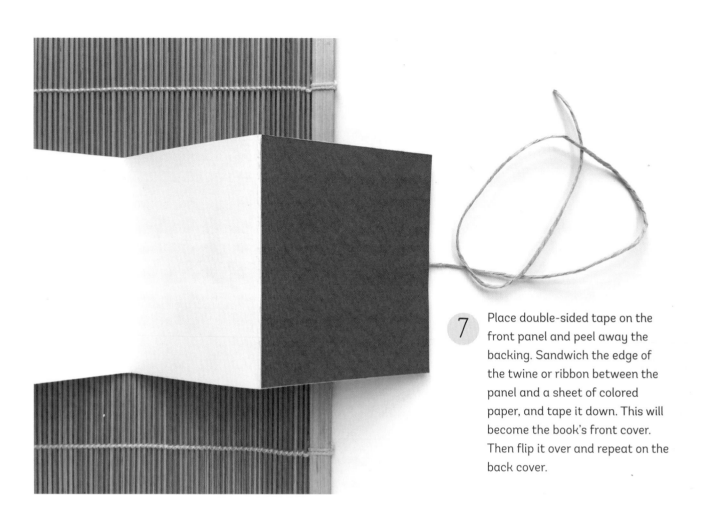

7 Place double-sided tape on the front panel and peel away the backing. Sandwich the edge of the twine or ribbon between the panel and a sheet of colored paper, and tape it down. This will become the book's front cover. Then flip it over and repeat on the back cover.

8 Make a title panel for your book using a small piece of card stock; then hand letter the title.

9 (Opposite) Fill in the panels of your concertina book. Draw or paint one plant per panel using your chosen medium.

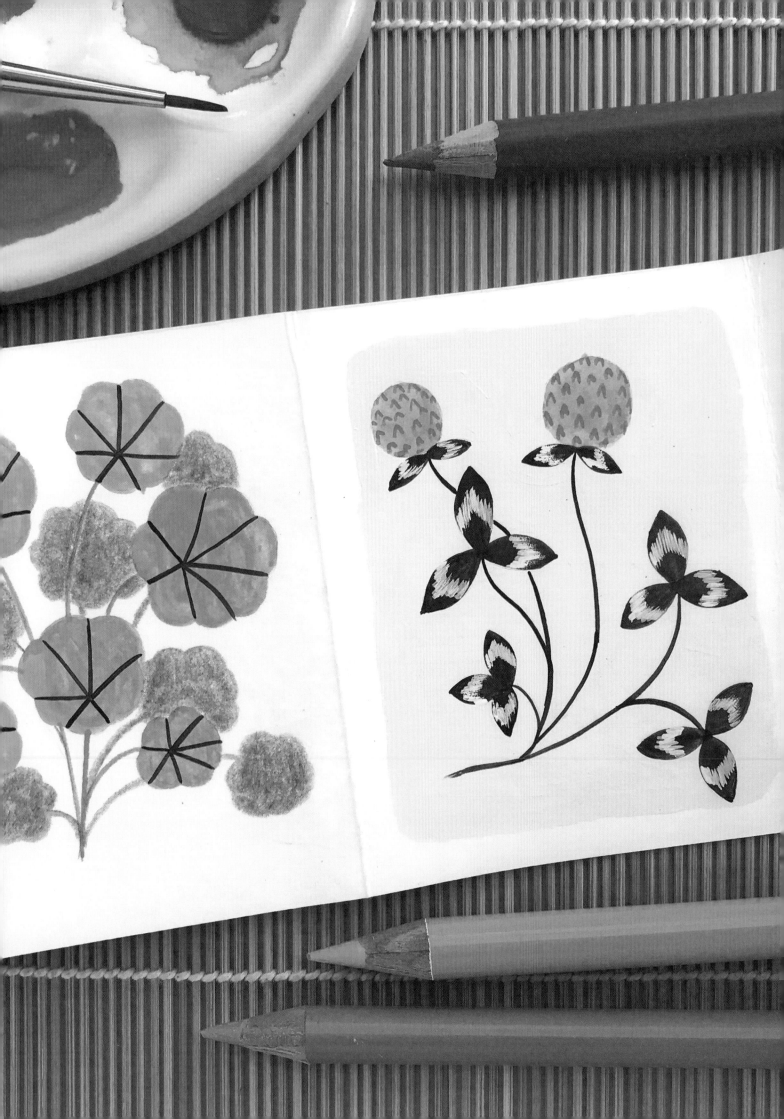

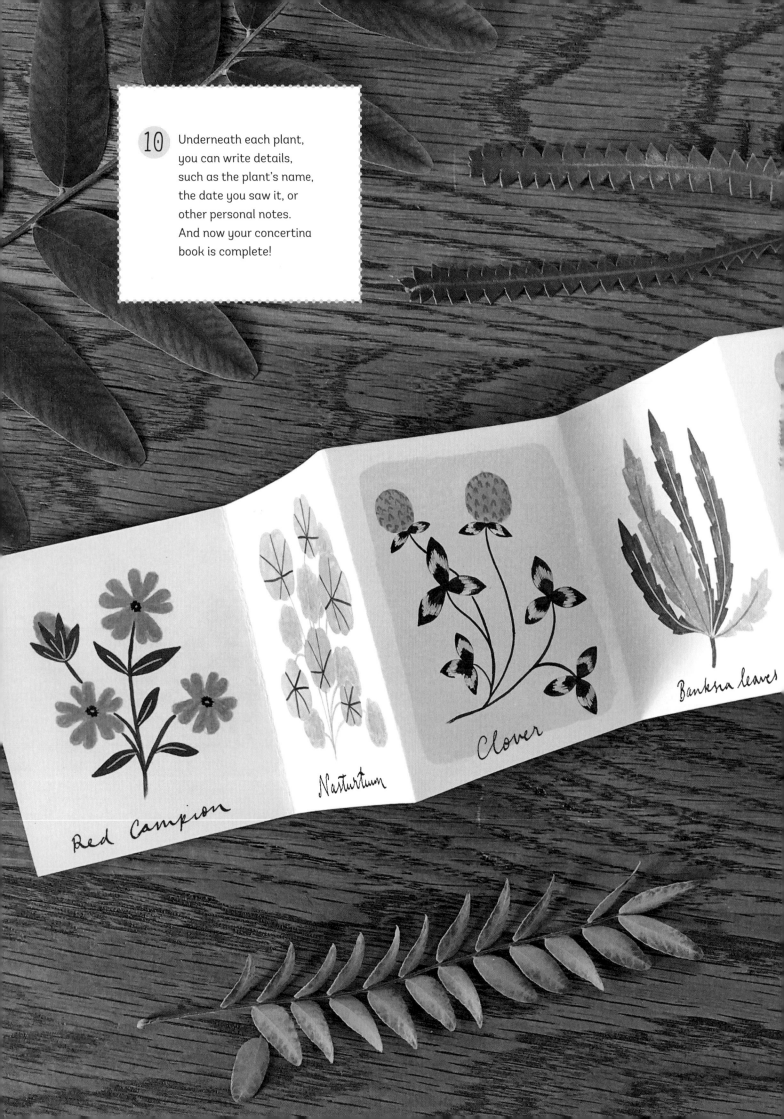

10 Underneath each plant, you can write details, such as the plant's name, the date you saw it, or other personal notes. And now your concertina book is complete!

Red Campion

Nasturtium

Clover

Banksia leaves

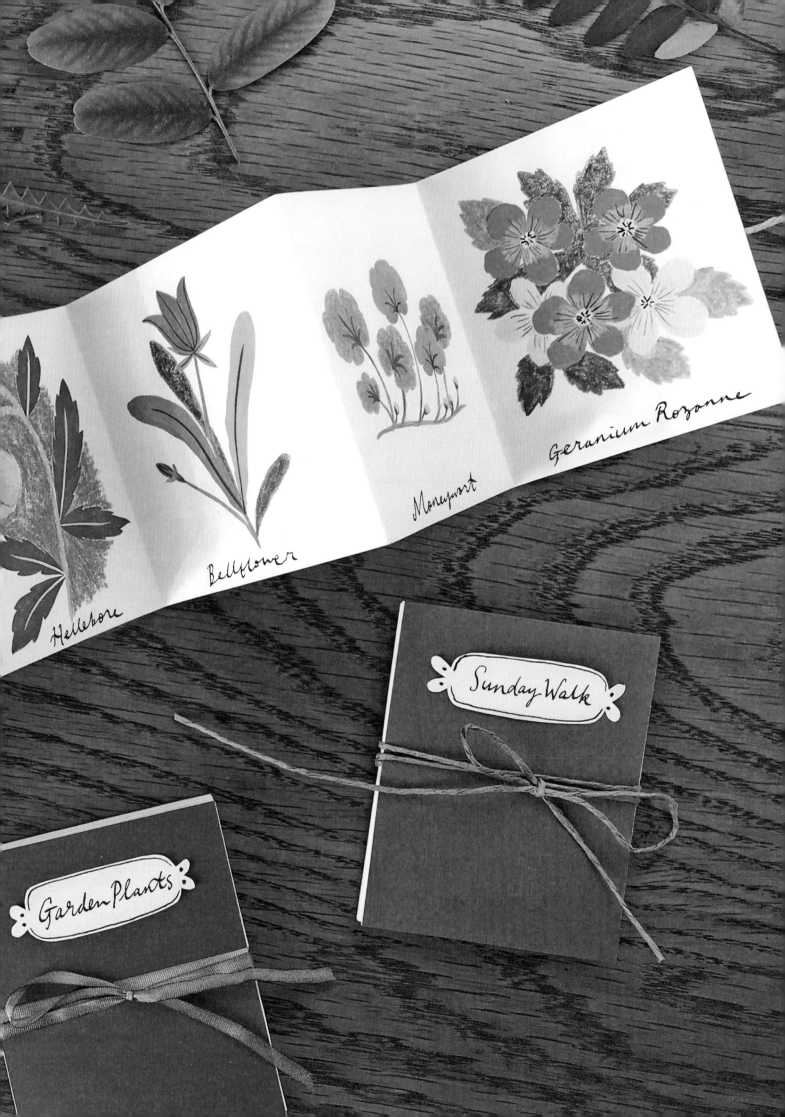

Hellebore

Bellflower

Moneywort

Geranium Rozanne

Garden Plants

Sunday Walk

CARD & ENVELOPE

Using some of the moths you practiced drawing for the exercises in this book (see pages 70 and 73), let's make a sweet card to give to a friend or relative. Complement it with a decorative handmade envelope for a personal touch!

Tools & Materials:

- Pencil
- Heavyweight sheet of 4" x 3" white card stock (300gsm)
- Scissors or a utility knife
- Gouache paints
- Fine-tipped round paintbrush
- Colored pencils
- Colored paper
- Bone folder tool
- Double-sided tape

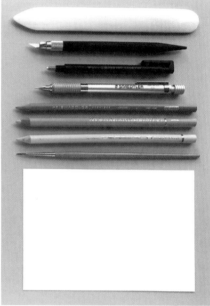

1

Draw the outline of a moth onto the white card stock. Lightly draw the body, as well as a symmetrical floral pattern on the wings.

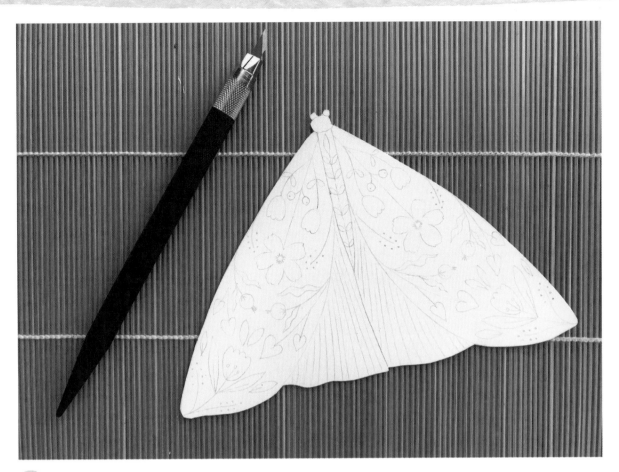

2 Cut out the moth using scissors or a utility knife.

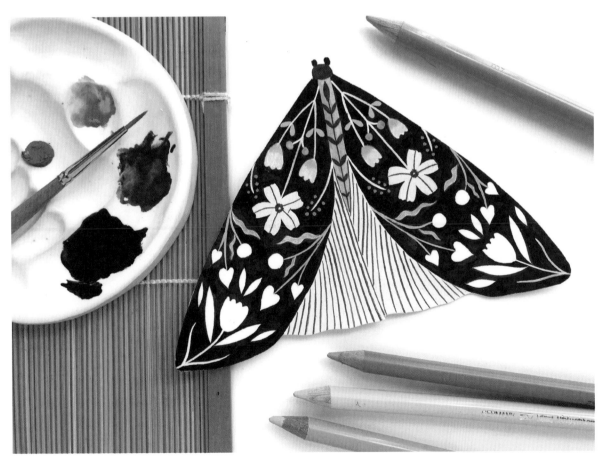

3 Color in the moth with gouache and colored pencils. Then you can write a sweet message to the recipient on the back.

Envelope

Now, make an envelope using a sheet of colored paper. Photocopy or scan and print the template provided, or draw your own outline. Then place the template on a light box or window and put the colored paper on top. Trace the template and cut it out. Then use the following steps to make an envelope, applying a bone folder tool to all folds.

——————— Cut line

- - - - - - Fold line

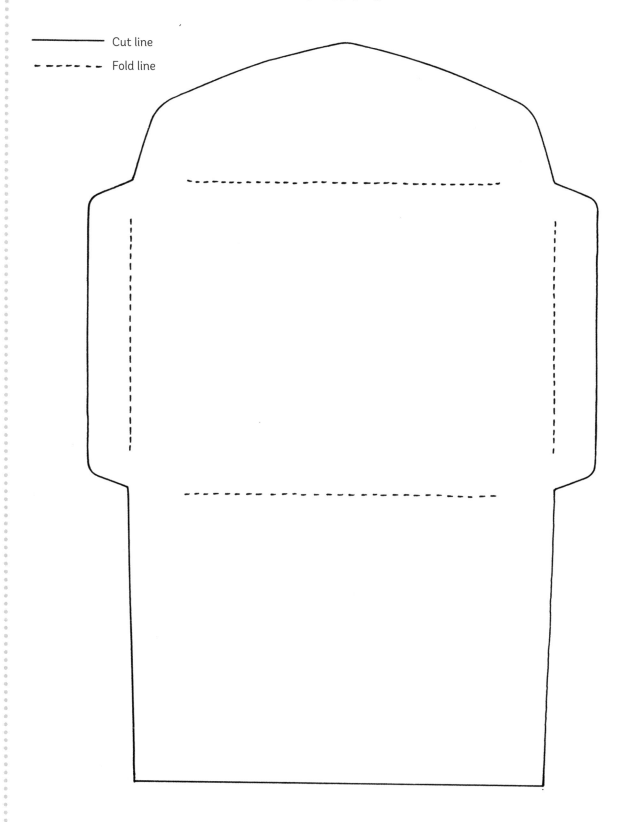

4 Cut out the shape of the envelope.

5 Using the bone folder tool, fold the side flaps inward.

6 Place double-sided tape on the side flaps.

7 Fold up the bottom flap onto the double-sided tape.

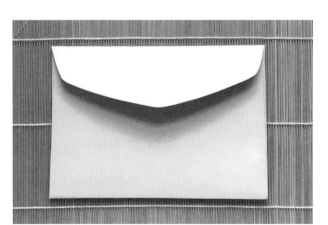

8 Fold down the top flap.

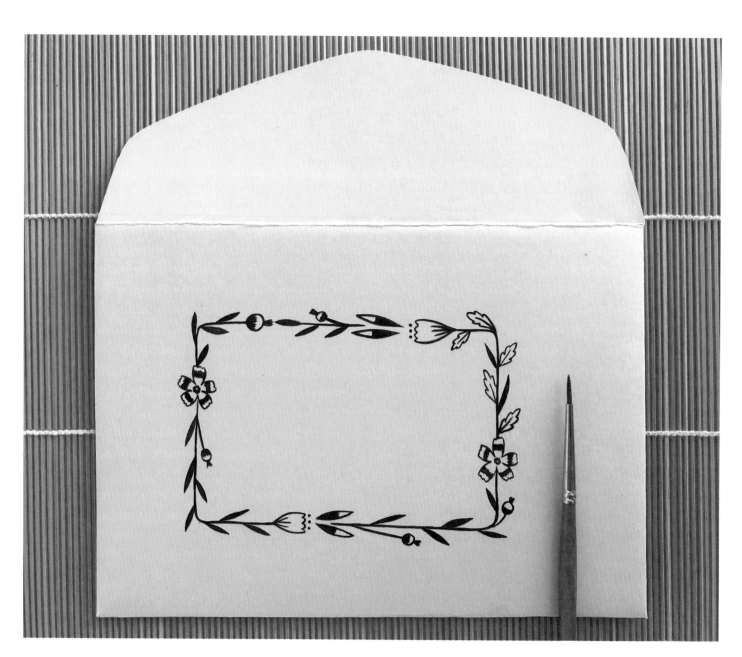

9　Now, back to the moth card! Decorate the front of the envelope with a frame to go around the recipient's name and address. If using paint, choose acrylic or an acrylic-based gouache so that it is water-resistant once dry.

10　(Opposite) Your beautiful moth card and envelope are now ready to send!

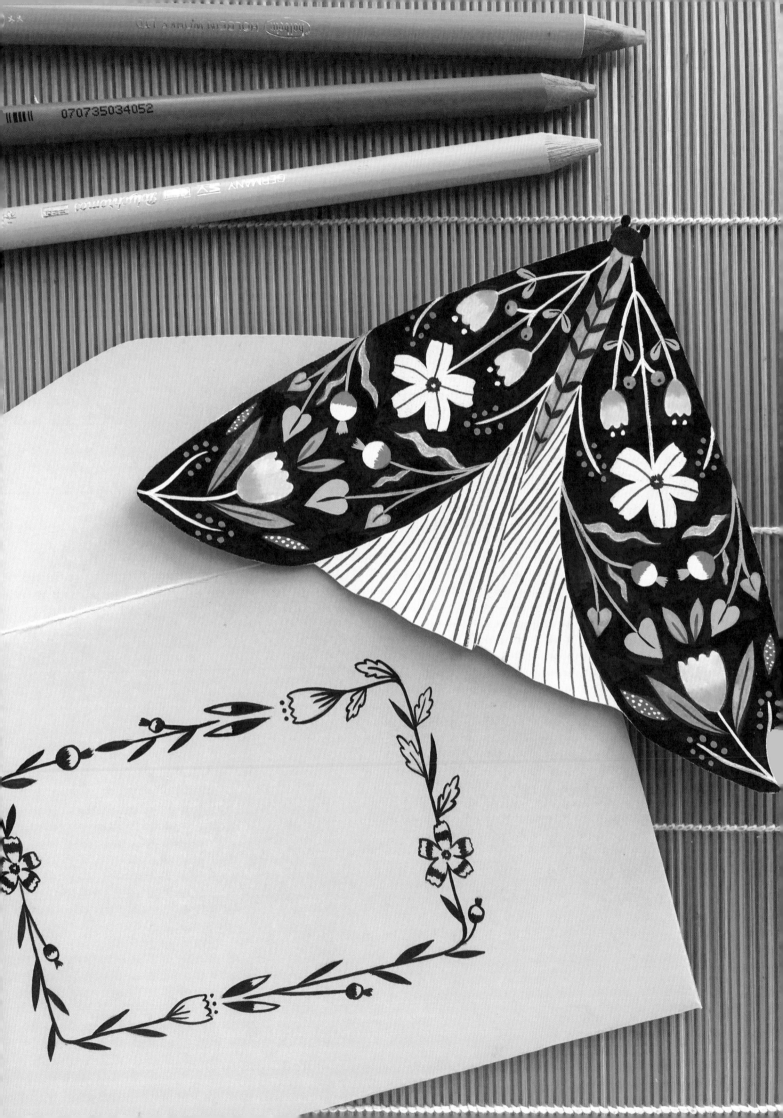

BOOKMARK

Bookmarks are useful items that make lovely gifts as well. Using black gouache and a fine-tipped brush, create your own house-shaped bookmark featuring lots of small details and patterns.

Tools & Materials:

- Heavyweight card stock (300gsm) trimmed to desired bookmark size

- Pencil

- Scissors or a utility knife

- Single-hole punch

- Black gouache

- Fine-tipped round paintbrush (size 0 or 1)

- Twine or string

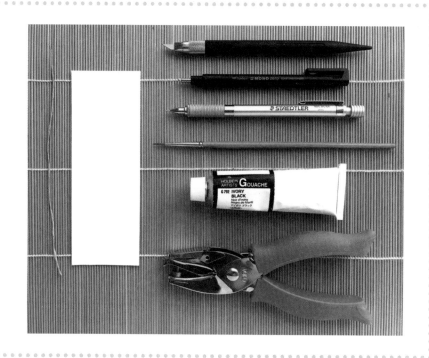

At the top of the card stock, draw a pointed roof.

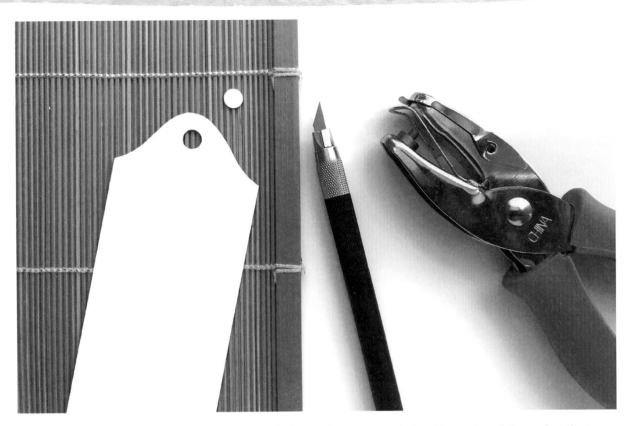

2 Cut around the pencil line; then use the hole punch to create a hole in the center of the roof at the top of the card stock. You will thread string or twine through here.

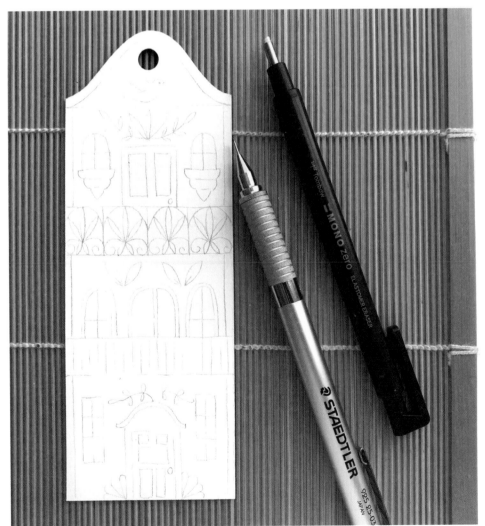

3

Using a pencil, lightly draw the rest of the house onto the bookmark. Include any details, such as plants, balconies, windows, and shutters.

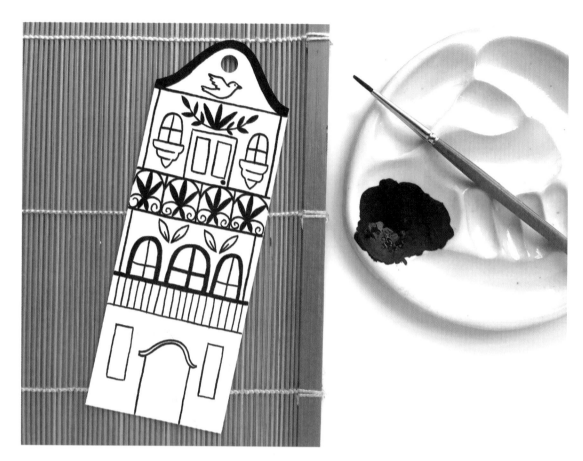

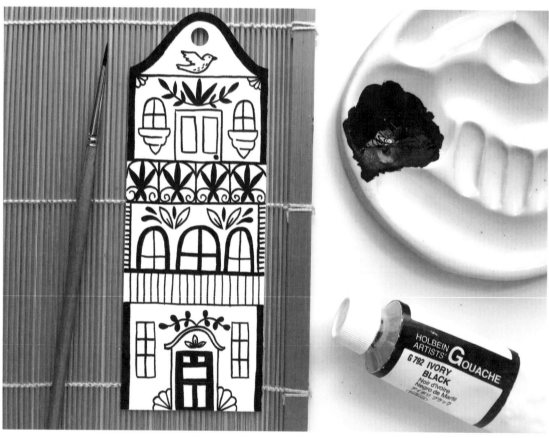

4 Mix a small amount of water into some black gouache on a palette; then paint over the pencil lines with a fine-tipped brush.

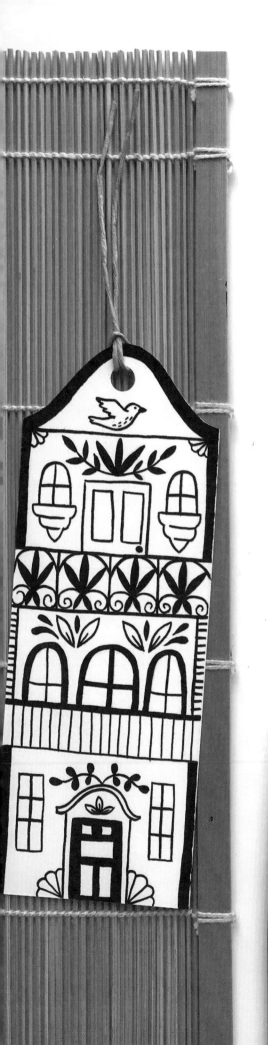

5 Fold the twine or string in half and insert it through the hole at the top of the bookmark. Loop the loose ends through the hole to attach to the bookmark. It's now ready to use!

group of poems written by the ever-secretive Emily, who had not in-tended to show them to anyone. Anne then revealed that she too had been writing verse, and Charlotte proposed that they publish a com-ined collection of their poetry—sing pseudonyms to safeguard their ivacy. Emily's misgivings were on overcome, and in 1846 a sm ume appeared bearing the nam urrer, Ellis, and Acton Bell. k, published at their ow e, was hardly a sensation o copies were sold. But of their words in ation enough. The s time completing in progress, ar using the sam eir debuts as ritical receptio g Heights, no piece, was gnes Grey fa a second n the next year, The Te Hall, sold quite well. of Jane Eyre was on a altogether. The first sold out, then the months the mysterio was literary England's conversation. Ev vas in the dark unti ne visited London isclose their true ide Yet the joy of this t be cut short by a series blows. Branwell's de ber 1 was follow mor by Emi tub five mo the ss took its third victim, Ann otte continued to live in Hawor with her father; he was her only family now, and this the only place she could ever call home. Sheer

strength curring he strug the autum Shirley, wa ed London isher. Ther otable fig illiam Ma s of the b this tim was als later succ ain de

B come. Some thoughts on piece are offered in an Aft Julie Erlich, a writer and has taught at several colle New York area.

h, new ruly gedy duri icine coul 1855, ed at

Jane the au h a h

© 1984 The Reader's Digest Association, Inc.
© 2000 Reader's Digest (Australia) Pty. Ltd. (A.C.N. 000 565 471)
© 2000 Reader's Digest (New Zealand) Limited

ABOUT THE ARTIST

Flora Waycott was born in England to an English father and a Japanese mother. When she was six years old, her family moved to Japan, where Flora spent five years surrounded by the colors, sights, and creativity of Japanese culture. Her parents bought Flora's first paint set soon after they arrived and enrolled her in art classes, where she would draw, paint, and make crafts with other children from her neighborhood. These years spent in Japan played a large role in shaping her creative path.

After graduating from Winchester School of Art with a textile design degree, Flora worked as a textile designer in London before moving to New Zealand. It was there that she started to refine her drawing and painting skills, eventually leading to work as a full-time artist and illustrator. Flora has worked with clients that include Quarto Publishing Group, Chronicle Books, HarperCollins Publishers, The Museum of Modern Art, and Mudpuppy, and her art has been featured in *Flow Magazine, The Uppercase Compendium of Craft & Creativity,* and *HGTV Magazine.*

Flora lives and works in Australia from her home studio in her leafy neighborhood. When she is not creating artwork, she can be found grabbing a snack at the local farmers market, going for walks in nature, baking brownies, traveling back to Japan, and working on numerous textile projects.